# ABINGDON
## THROUGH TIME
Pamela Horn

AMBERLEY PUBLISHING

First published 2009

Amberley Publishing Plc
Cirencester Road, Chalford,
Stroud, Gloucestershire, GL6 8PE

www.amberley-books.com

Copyright © Pamela Horn, 2009

The right of Pamela Horn to be identified as the
Author of this work has been asserted in accordance
with the Copyrights, Designs and Patents Act 1988.

ISBN 978 1 84868 599 4

British Library Cataloguing in Publication Data.
A catalogue record for this book is available from
the British Library.

Typeset in 9.5pt on 11pt Celeste.
Typesetting by Amberley Publishing.
Printed in the UK.

# Introduction

Much of Abingdon's early history was linked to the Benedictine Abbey, which dominated town life for over eight centuries, until its dissolution by Henry VIII in 1538. Now little remains of the once great monastery beyond a few street names and a scattering of medieval buildings, such as the late-fifteenth-century western gatehouse and St Nicolas' church. St Nicolas' was built around the end of the twelfth century for the abbey servants and was always the minor church of Abingdon. St Helen's, already under construction by the late twelfth century, remains the town's principal church. Other denominations have built their own places of worship over the centuries.

With the disappearance of monastic power, Abingdon developed as an agricultural marketing centre and woollen cloth producer. Under its charters of 1553 and 1556, there was to be a Monday market and also five fairs, the most important of which was the Michaelmas hiring fair. Agriculture remained the basis of the town's prosperity up to the twentieth century. Although woollen cloth manufacture declined as a result of industrial developments elsewhere, this was partly compensated for in Victorian times by the growth of a large-scale business in cheap ready-made clothing. The firm of Clarke's employed around 1,850 workers in 1864, 350 of them in its West St Helen Street factory and the rest working in their own homes. Clarke's eventually went into voluntary liquidation in 1932.

Another important nineteenth-century firm was Morland's brewery. Brewing was long established in Abingdon when in 1861 Edward Morland purchased the Eagle brewery in Ock Street. For well over a century Morland's remained a major employer in the town, both at the brewery and through the public houses it owned. Then in 1999 it was taken over by a rival brewery, Greene King. They closed the Abingdon business the following year, with the site subsequently developed for housing.

Given the town's role as a marketing centre, it is perhaps not surprising that in the 1890s it had 35 public houses and 10 beer retailers for a population of under 7,000. By the early twenty-first century that had changed, with some public houses demolished and several converted for use as private houses or for other purposes.

Minor trades included the manufacture of sail cloth, sacking and ropes, the production of leather, and the making of mats and carpets. In the twentieth century, a boost was given to employment by the opening in 1929 of the MG car factory in part of the Pavlova Leather Company's premises off Spring Road. Employee numbers rose to around 1,200 in 1978, by which date the firm enjoyed an enviable reputation for its high quality sports cars. In October 1980, however, the factory was closed as part of a reorganization by its owners, British Leyland. Demolition began soon after and the site was subsequently redeveloped as a business park.

In Victorian and Edwardian times, the town had a wide range of shops and small businesses, some of them owned over several generations. However, in the late twentieth century the appearance of large multiple stores and a retail park undermined their competitiveness and many closed or changed hands rapidly as owners found it difficult to carry on. That even applied in the new Bury Street shopping precinct, built in the later 1960s. In 2009, its name was changed to the Abbey Shopping Centre.

For centuries the river Thames provided a trading link with the outside world, but by the early twentieth century that role had diminished. In recent years it has been pleasure boats that have plied up and down during the summer rather than commercial craft. In 1810, the arrival of the Wilts and Berks canal provided another transport alternative, with the coal wharf particularly busy by the 1830s. The railway arrived in 1856 when, after lengthy debate, a branch line was constructed to connect the town to the main Great Western Railway. The Great Western ran the branch line under a leasing scheme before taking it over in 1904, but the arrangement was cumbersome. In 1963, the line was closed to passengers, although goods traffic continued to use it into the late 1970s. The station building was demolished in May 1974. The canal company, meanwhile, finally collapsed in 1914.

During the late twentieth century, Abingdon's housing expanded rapidly and there was a growth of industrial and retail trading estates on the town's periphery. Population rose from about 6,500 in 1901 and just under 11,000 in 1951 to around 34,500 in the early twenty-first century.

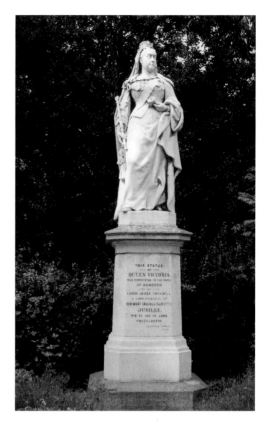

**Market Place and Queen Victoria**
The market place was decorated for Queen Victoria's Diamond Jubilee in 1897. On the left is the corn exchange. The statue of Queen Victoria was erected in 1887 at the sole expense of E. J. Trendell, JP, to celebrate the Queen's Golden Jubilee. In 1946 it was removed to the Abbey grounds, where it still stands in September 2009.

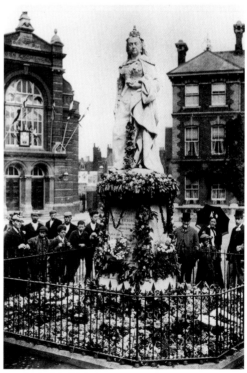

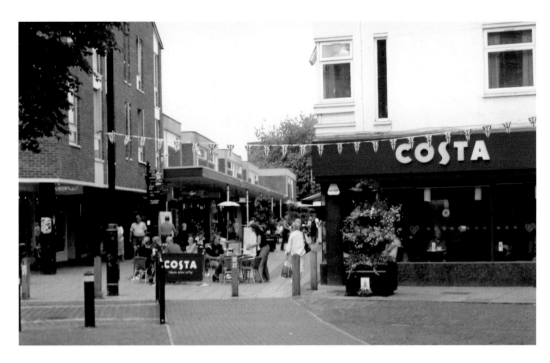

**Market Place**
Another view of the market place in 1890. To the rear is the Queen's Hotel, built in 1864 on the site of the old Queen's Arms. It was demolished in 1966 to make way for a new shopping precinct. To the centre left is the Corn Exchange, constructed in 1885-86 to sell corn by sample on market days. The upper floor was used for social events. On the far left is the London and County Bank, rebuilt in 1885-6. It is the only building to survive of those shown and is now occupied by the National Westminster Bank. In January 2006, the Bury Street shopping precinct was in full swing, with Costa coffee house on the site of the Queen's Hotel.

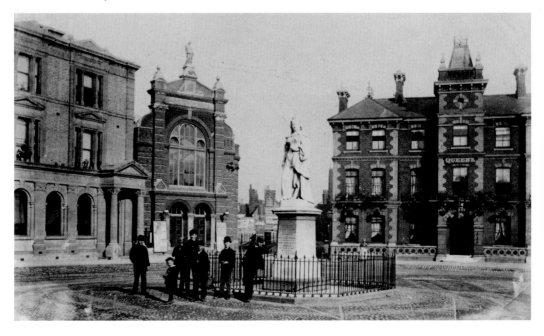

## Corn Exchange and Bury Street Shopping Precinct

The interior of the Corn Exchange's upper room, probably decorated for Abingdon School's Founder's Day celebrations, early in the twentieth century. Demolition of property in and around the Bury Street area began in the mid-1960s, to make way for the new shopping precinct, which was opened in 1970. This photograph was taken in March 1979.

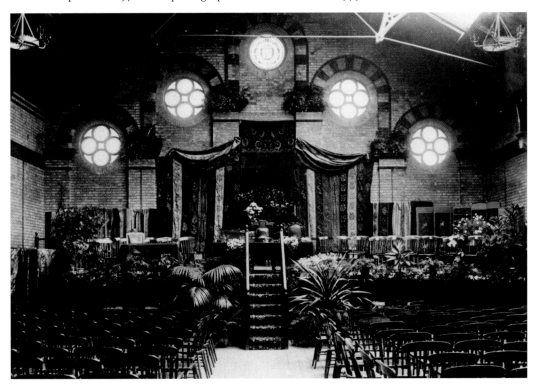

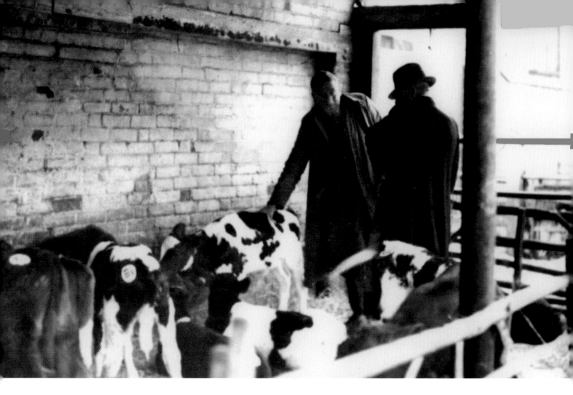

### The Cattle Market

Farmers in the late 1940s attending the weekly Monday cattle market. The market was opened in 1885 off Bury Street and at its peak 100 cattle and 200 sheep were sold each week. It was closed in 1958 on account of inadequate facilities. Occasionally an animal escaped and ran into the town along Bury Street, thereby causing great consternation. After the closure of the market, the site was used as a temporary car park before the redevelopment of the Bury Street area in the 1960s. In 1958, the cattle market was moved to a site near the railway station, but that too closed in the late 1980s.

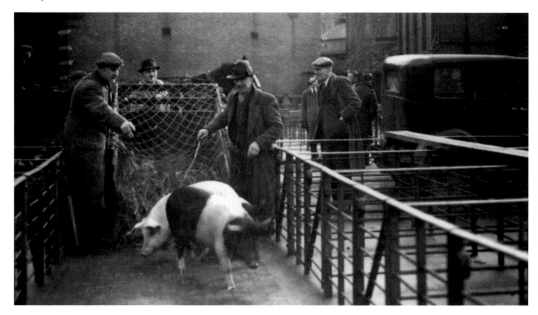

## Market Place and County Hall

The north-east corner of the market place *c.* 1950, with Speedwell shoe repair service in the corner where Stroll In is now located. In the centre on the right was the Old Globe public house, which was closed in 1960. Car parking continued in the market place until the late 1970s, when steps were taken to end it. The County Hall, sometimes called the Town Hall, is shown *c.* 1930. The large shop to the rear, on the left, was Shepherd and Simpson, tailors and outfitters. The County Hall was built between 1678 and 1684 in baroque style, to replace an old timber-framed market house. It had three main roles: the basement served as a store, the open ground floor was used as a market and the first floor was a law court for the County Assizes. Abingdon hosted the Summer Assizes until it ceased to be a county town in 1869. The County Hall was also a venue for plays, penny readings, concerts, political debates and other events. Since 1920, it has housed Abingdon's museum.

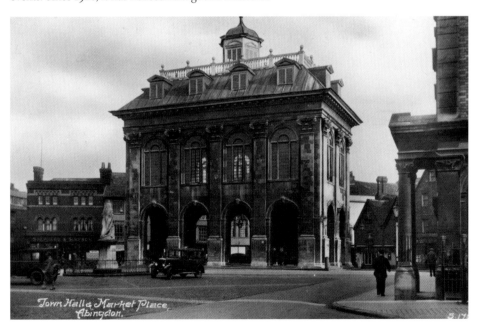

Town Hall & Market Place Abingdon.

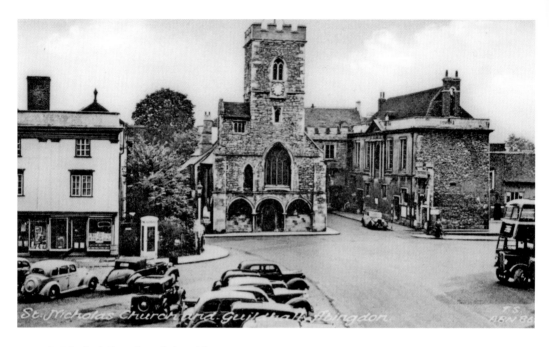

### St Nicolas' Church and the Abbey Gateway

St Nicolas' church, the medieval Abbey gateway and Richard Harker's shop, which was selling clocks and musical instruments *c.* 1880. Later the shop became a reading room and coffee house before being taken over by Hays & Son as their butcher's shop from 1894 to 1938. Behind the shop was the entrance to the Roysse Room, where the old Abbey Grammar School was refounded by John Roysse in 1563 as a free school for sixty-three boys. The school remained on the site until it moved in 1870 to new purpose-built premises near Albert Park. By the mid-twentieth century the demolition of the former Harker's shop and neighbouring premises in 1938 to widen Bridge Street had opened up the view of the Guildhall.

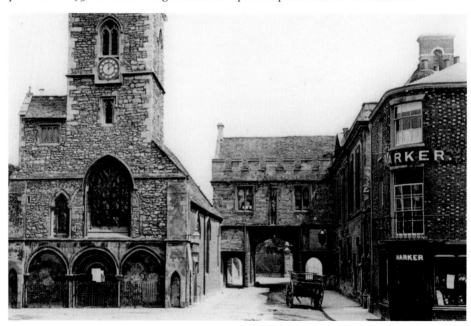

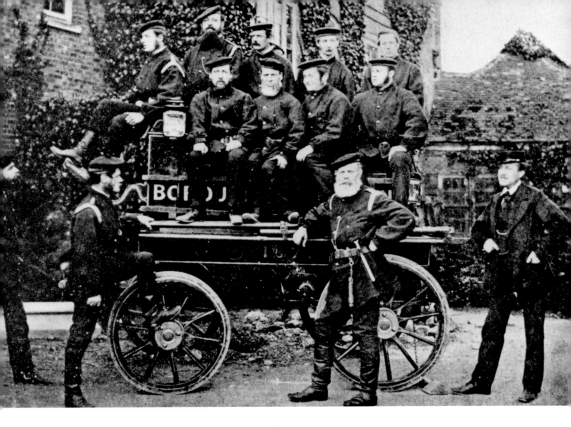

## The Guildhall, St Nicolas' Church and the Abbey Precinct

St Nicolas' church and the Abbey gateway as seen from the market place in September 2009. The gateway is now barred to traffic and the 1938 demolition opened up the view of Roysse Court, formerly Roysse's school yard. This was made into a garden in 1951. The elaborate balustraded staircase at the end of the Guildhall was added in 1958 as a fire escape for the Council Chamber on the first floor. The Abingdon Volunteer Fire Brigade was formed in 1871 after a serious fire in Bath Street. It met first in the Abbey precinct, with a two-bay fire station built in the former Roysse school yard in 1881. In 1914, a new fire station was opened behind the Corn Exchange.

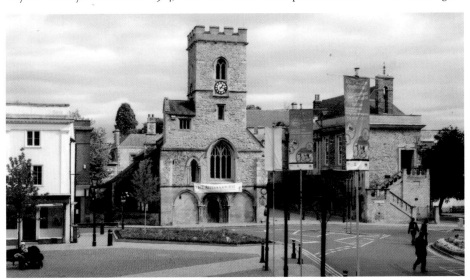

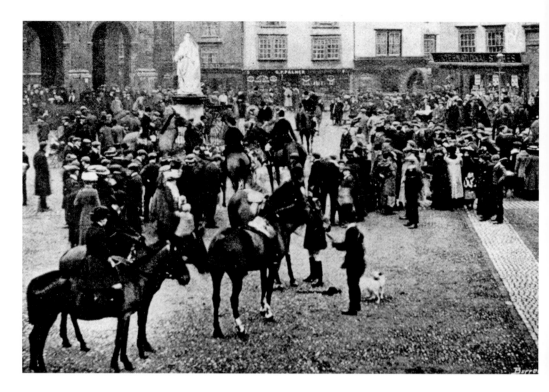

## Market Place and High Street
A meeting of the Old Berks Hunt in the Market Place before 1914 and a bird's eye view of the High Street looking west *c.* 1900. The large shop on the right with the awnings was Chivers' drapery store.

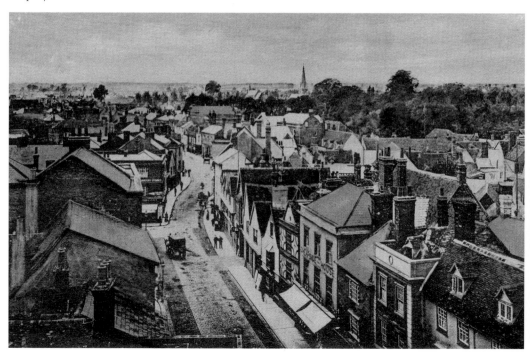

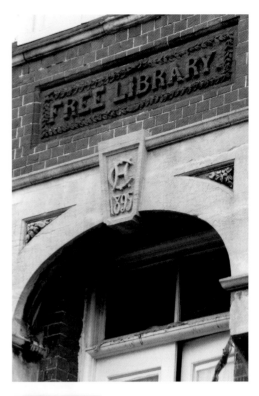

**The High Street and Public Library**
Abingdon High Street looking east towards
the County Hall *c.* 1935. On the left is the
public library, built in 1895 and formally
opened the following April by the Earl of
Abingdon. It stayed on the site until 1976
when it transferred to its present location in
the Charter complex. A surviving sign above
the former public library building in the High
Street proudly proclaimed it to have been a
'free library'.

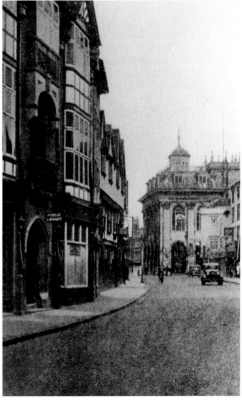

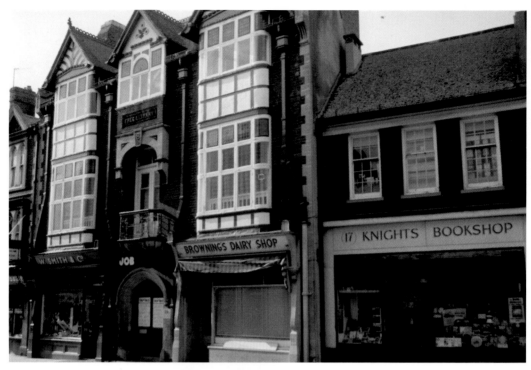

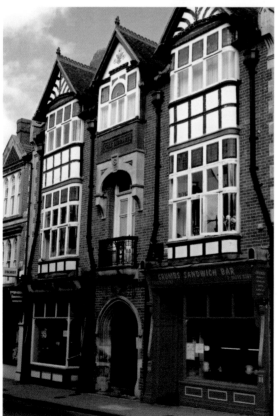

### The High Street

The High Street in July 1979. The former public library had become a Job Centre and was flanked by W. Smith & Co., chemists, and by Browning's Dairy Shop. By September 2006, the Job Centre had moved and, while Smith's remained, Browning's Dairy Shop had been replaced by a sandwich bar. That is still the situation in 2009.

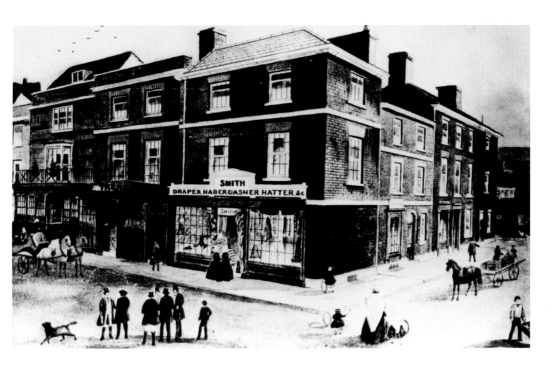

## The High Street

The High Street in the nineteenth century in a more leisurely age. The earlier picture, taken
*c.* 1850s, shows the High Street and the corner of West St Helen Street. A special pedestrian
crossing has been installed at this point nowadays to enable people to cross the road.
The later photograph shows a procession of governors, masters and boys from Abingdon
School in the 1890s, probably celebrating Founder's Day.

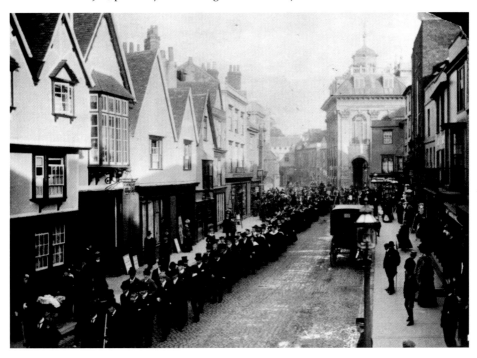

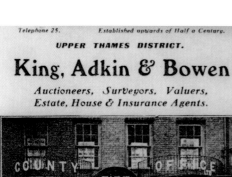

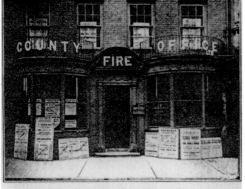

Telephone 25.          Established upwards of Half a Century.

**UPPER THAMES DISTRICT.**

# King, Adkin & Bowen

*Auctioneers, Surveyors, Valuers,*
*Estate, House & Insurance Agents.*

**Sales by Auction and Private Treaty** of Property, Shares,
Farming Stock, Timber, Household Furniture, etc., on moderate
terms.      **VALUATIONS** for Tenant Right, Estate Duty,
Mortgage, Transfer and Compensation.

Reports, References, Arbitrations. Estates and Properties managed. Particulars
of Unfurnished and Furnished Houses, Farms and Properties to Let or for Sale
on application. Sales of Fat and Store Stock held in Abingdon and Oxford.
Agents for the County Fire Office Ltd., Alliance Assurance Co., and the Ocean
Accident and Guarantee Co.    RATES ON APPLICATION.

Offices : **10, High Street, Abingdon,** and at **Wantage.**

**The High Street**
An advertisement by King, Adkin &
Bowen at No. 10 High Street in 1912. The
multiplicity of placards shown announced
property sales of one kind or another. In
2009, the same premises were occupied by
the estate agents Buckell and Ballard. A bus
stop obscures some of the frontage.

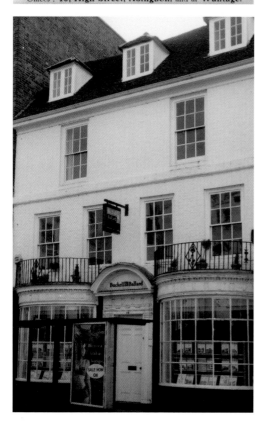

## The Changing Face of the High Street

E. H. Beesley's impressive shop in the High Street features in this advertisement *c.* 1921. As was common at the time, the windows were crammed with stock. Beesley & Son began advertising their outfitter's business in Kelly's *Directory of Berkshire* in 1887. They were then located at 5 High Street. By 1895 they had moved to 24 High Street, and in the 1901 Census of Population Ernest H. Beesley, aged thirty, was living over the shop with his wife and two-year-old daughter. The firm remained in business until 1984, when the men's outfitters, Dunn & Co., took over the property, but by 2009, 22 and 24 High Street had ceased to be connected with the clothing trade. They were occupied by a bookmaker and a newsagent respectively.

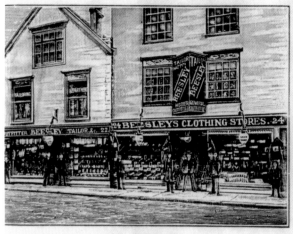

# E. H. BEESLEY,
### Tailor, Clothier and Complete Outfitter,
### - 22 & 24, High Street, ABINGDON. -

### DEPARTMENTS.

| | |
|---|---|
| Ready-made Clothing. | Hosiery, all kinds of Underwear, &c. |
| Hats, Caps, Best Makes. | |
| Woollen Warehouse. | Waterproof Coats, Capes, etc., etc. Umbrellas. |
| Rainproof Coats. | |
| Shirts, Collars, Ties and Gloves. | Tailoring, Ladies' and Gent.'s |
| Gent.'s Boots, Shoes and Leggings. | Tailors' and Dressmakers' Trimmings. |
| Working Men's Clothing of every description. | Travelling Bags and Trunks. |

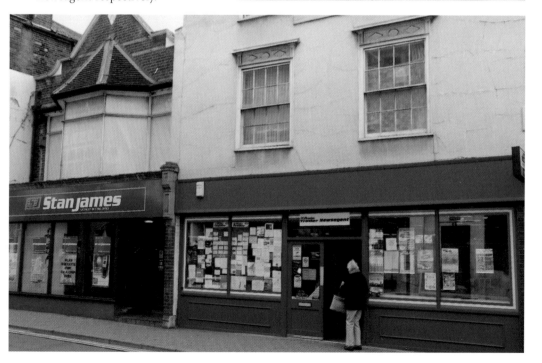

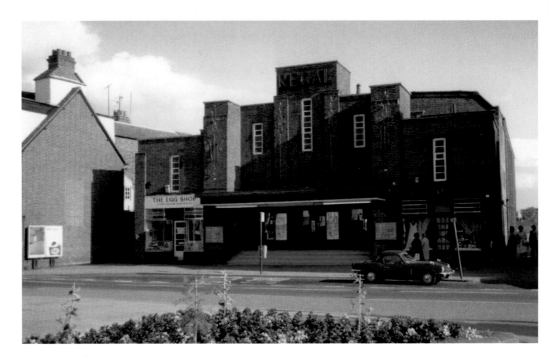

## The Square

The unveiling of the war memorial in The Square by the Earl of Abingdon on 11 September 1921 and the Regal Cinema, facing the war memorial, in July 1979. It was flanked by the Egg Shop and Marie's lingerie shop. The cinema was built in 1935 in the fashionable Art Deco style, but in 1979 it became a bingo club. It then briefly returned as a cinema in the 1980s before finally closing. Despite protests it was demolished in March 2003. Marie's lingerie shop has re-located to Bath Street.

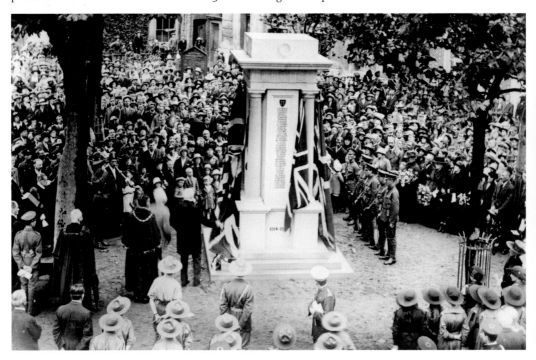

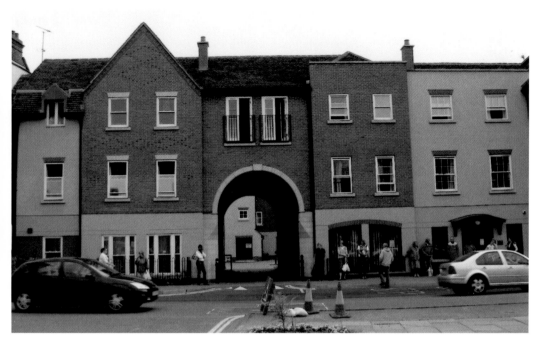

## The Square

The Regal cinema site by June 2006 had been developed as a housing and office complex called Regal Close. The rather disconsolate people in a queue were waiting for a bus. Reflecting a very different age was the Rising Sun Temperance Hotel at the corner of The Square, by the High Street, *c.* 1895. It became a temperance hotel in 1894, although a public house had been on the site since the eighteenth century. At that time and for some years thereafter The Square also served as a sheep market. The Rising Sun was demolished in 1900 but in the mid-1890s it served as a base for some of the carriers trading between Abingdon and the surrounding villages.

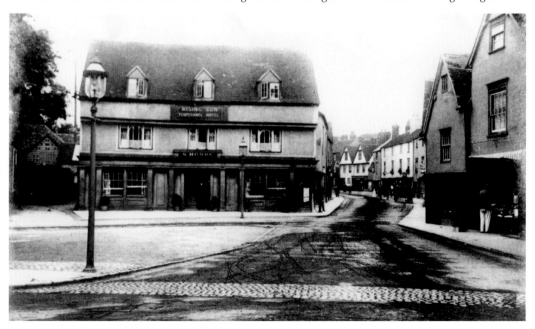

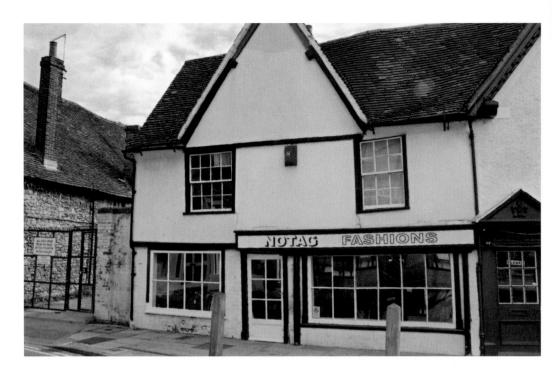

## The Square

No. 4 The Square was a tobacconist's shop run by the Gibbens family *c.* 1930. From the late 1880s to the early twentieth century the Tyrrells had owned it, with William Henry Tyrrell running the shop and his wife advertising herself as a straw bonnet maker at the same address. When the Gibbens family sold their business, the property was taken over by Notag, a fashion shop, which still occupied it in September 2009.

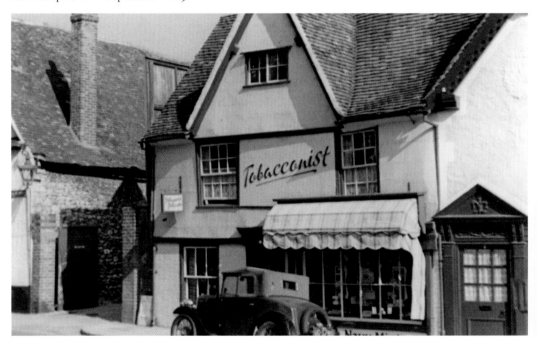

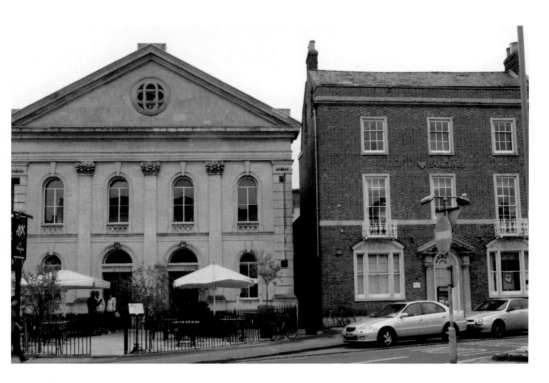

## The Square

The Congregational church in The Square was rebuilt in 1862, to replace an earlier meeting house constructed in 1701. In 1978, after a ten-year trial, the Abingdon United Reform church, as it had become, joined with the Methodists to form Trinity church, located in Conduit Road. In July 1979, as the photograph shows, it was up for sale and when it changed hands in 1980 it became known as Pulpit House. By August 2009, it had become the Ask Italian restaurant.

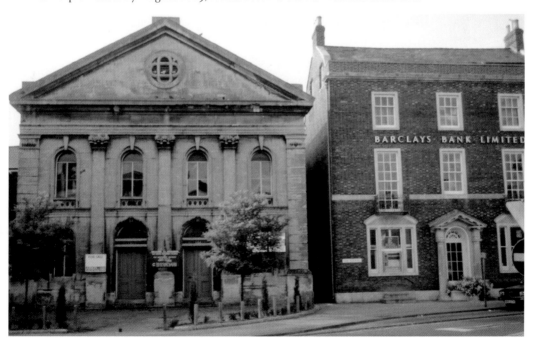

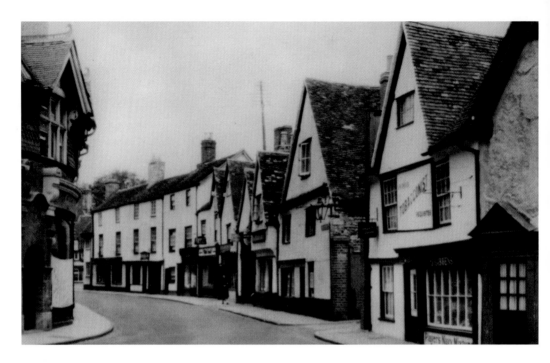

## Bath Street

The large building in the centre of the older photograph was the Three Tuns public house, 29 Bath Street, *c.* 1895. The landlord, John Thomas Gibbens, combined his role as innkeeper with that of a pork butcher, as did his successor, Alfred Saunders. The Three Tuns remained open until at least 1912 but was then demolished, with the site incorporated into the premises of the agricultural engineers, Benjamin Ballard & Son. The mid-twentieth-century photograph provides a tranquil view of Bath Street, with its numerous small businesses.

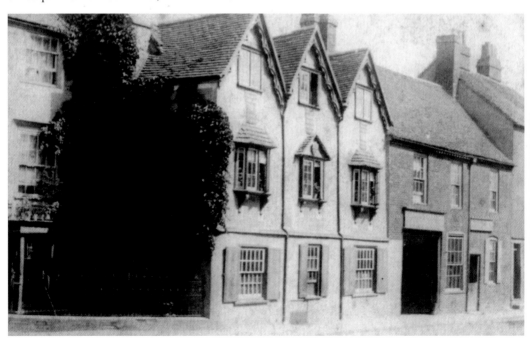

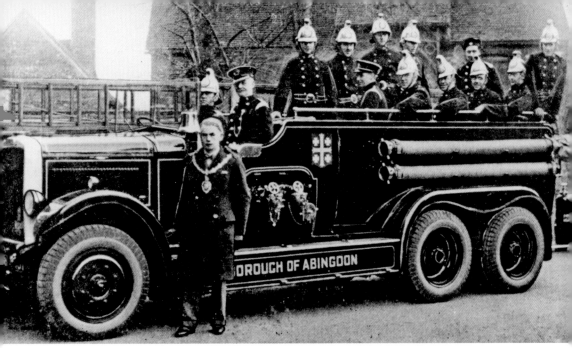

## Broad Street and the Gibbens family

Joseph Gibbens & Son, saddlers and harness makers, in the 1920s at No. 38 Broad Street, on the corner with Bath Street. At that date the firm also sold golf bags, trunks, attaché cases and a wide selection of other leather goods. At the 1901 Census of Population the widowed Joseph Gibbens senior lived over the shop with his twenty-two-year-old schoolteacher daughter and another daughter, aged seventeen, who may have kept house. In 1933, members of the Abingdon Volunteer Fire Brigade, including Joseph Gibbens junior, displayed their new pump. Mr Gibbens had then served the Brigade for forty years and since 1924 had been its chief officer. Sadly he died soon after the photograph was taken. He was seated at the front of the vehicle, on the left.

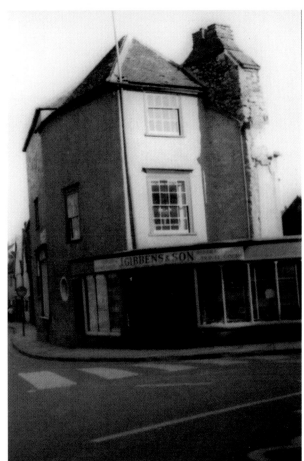

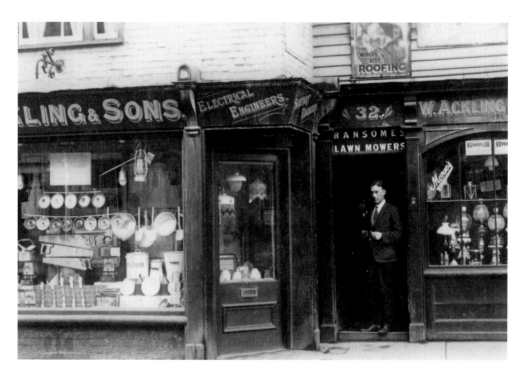

## Bath Street

The shop of William Ackling & Sons, general ironmongers and electrical engineers, at 32 Bath Street in the 1920s. It still sold large numbers of oil lamps. A member of the family was standing in the doorway. By September 2009 the former Ackling shop had become a café.

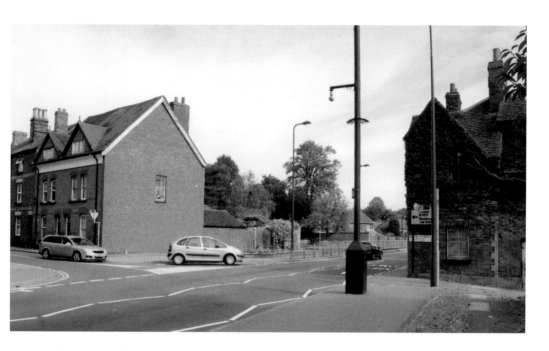

## Bath Street and Stratton Way

In 1969, the construction of the inner relief road, Stratton Way, bisected Bath Street, and an underpass was built to enable pedestrians to cross the road at busy times. Abingdon Cottage Hospital had been built in Bath Street in the Victorian years, with four foundation stones laid on 11 August 1885 by four leading female members of Abingdon society. It was on land given by the town's most important charity, Christ's Hospital, and initially it had ten beds. The photograph shows the hospital *c.* 1910. In 1930, a new hospital was opened to replace it at The Warren, Radley Road.

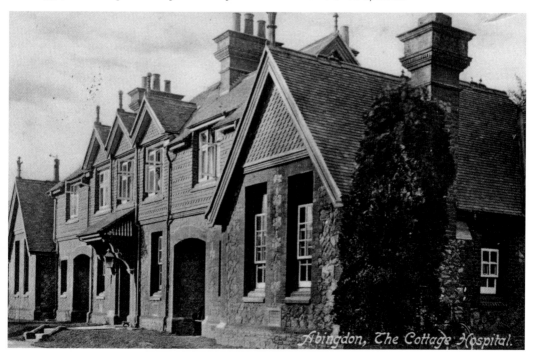

*Abingdon, The Cottage Hospital.*

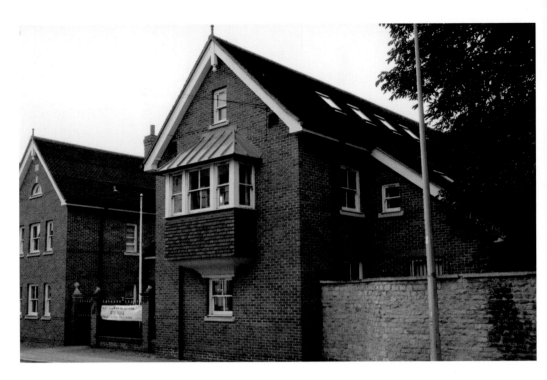

## Bath Street

In 2009, the site of the former Bath Street Cottage Hospital was occupied by Mercer's Court and included a new sixth-form block for Abingdon School. Something of the grounds of Abingdon School can be seen from Bath Street.

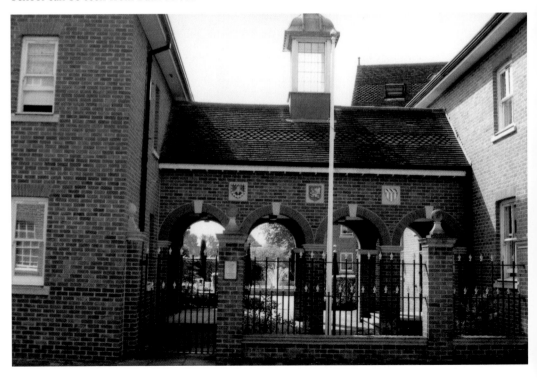

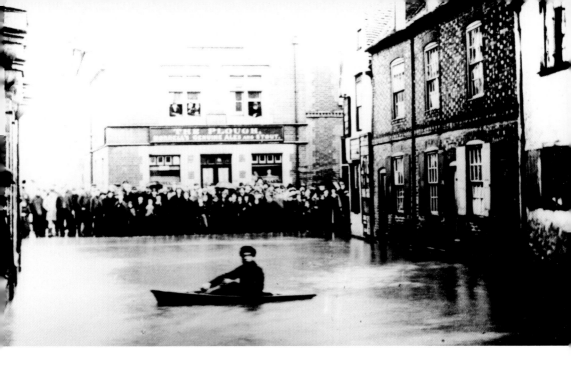

### The Bury Street Shopping Precinct and Broad Street

The Gibbens' shop in Broad Street was demolished in the final phase of the Bury Street redevelopment and the large Woolworth store, opened in 1972, occupied the site of the shop as well as of several neighbouring properties. In 2009, following the collapse of the Woolworth chain all over the country, it was closed. In the summer of that year, concern about flagging commercial outlets in the Bury Street precinct led to a change of name to the Abbey Shopping Centre and to plans being made to rejuvenate the area. Broad Street on 15 November 1894 presented a very different picture when a great flood led one hardy soul to resort to a rowing boat. Buildings on the left of the photograph were demolished to make way for the new multi-storey car park and the Charter complex in the 1970s. The onlookers were standing in front of the Plough public house in Stert Street.

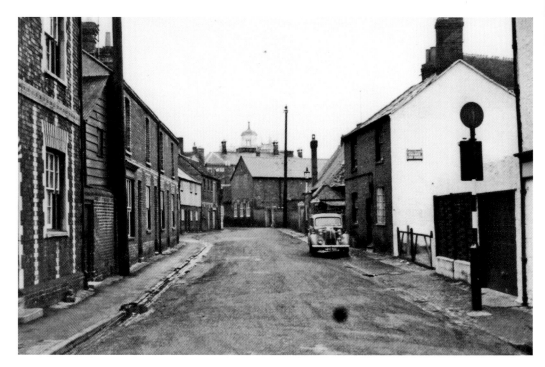

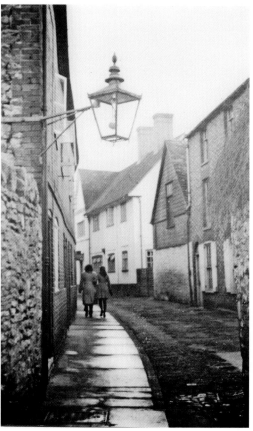

### Queen Street

Two views of Queen Street in the 1960s. The first was taken from Broad Street in 1963 and shows the roofs of the County Hall and the Queen's Hotel just visible in the background. The second shows the market place entrance of this very narrow and restricted street.

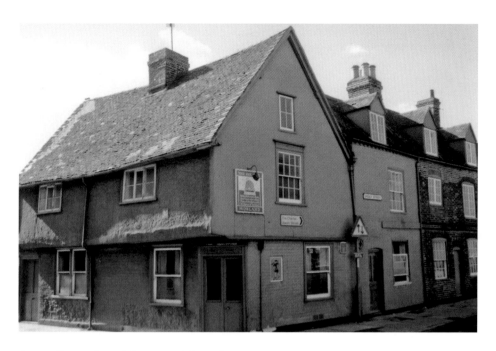

## Queen Street, Broad Street and Stert Street

The demolition programme of the 1960s and 1970s completely opened up Queen Street, and it has become largely a service area for nearby businesses. Near the Broad Street entrance to Queen Street in this March 1979 photograph was The Beehive public house, at the junction of Broad Street and Stert Street. The board fixed to the wall is popularly believed to refer to William Honey, who was landlord of The Beehive from at least the mid-1840s to the late 1870s. He was also town crier. The verse ran:

> Within this hive we're all alive,
> Good liquor makes us funny.
> If you are dry step in and try,
> The flavour of our honey.

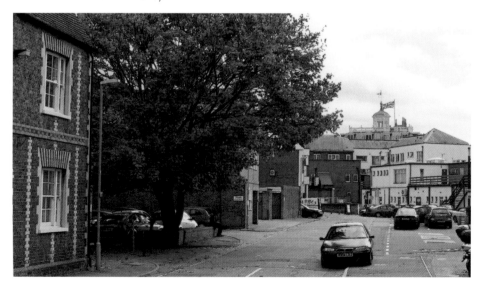

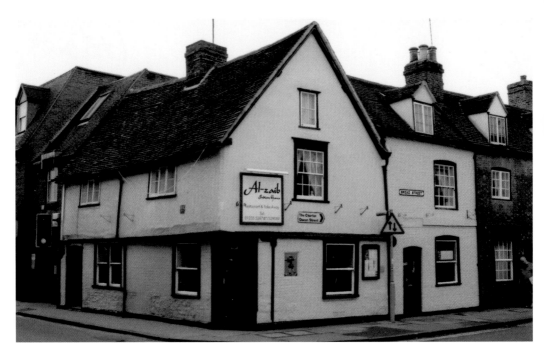

## Stert Street

By the summer of 2001, The Beehive had gained a 'notorious reputation for trouble' and there were frequent changes of manager. It was closed in June 2001 and after sale it became an Indian restaurant, Al-Zaib. Unfortunately, during renovation work the distinctive Beehive board, with its rhyme, disappeared. Opposite the entrance to Broad Street, by Station Road, was 63 Stert Street, in March 1979.

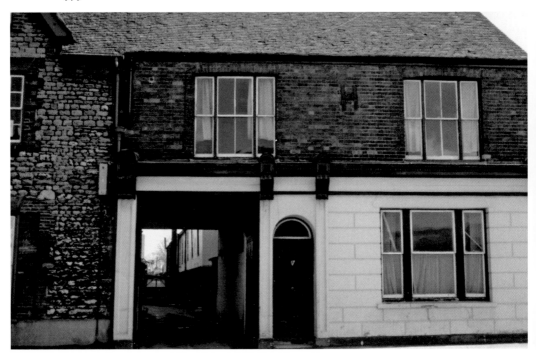

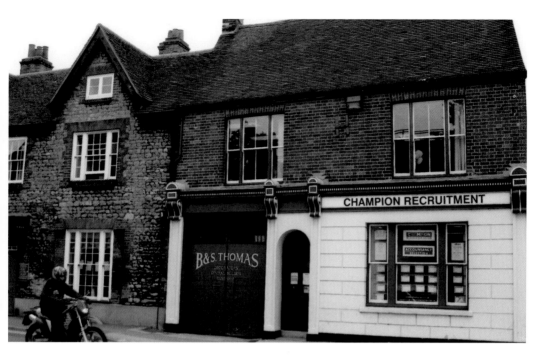

### Stert Street

No. 63 Stert Street had become a recruitment agency by June 2006. Its location, by the Old Station Yard, was a reminder of Abingdon's railway past. Below is a photograph of the railway station itself in *c.* 1860, with the original broad gauge track. This was changed to standard gauge in 1892 when the Great Western Railway, which ran it, was forced to conform to the gauge accepted by other railway companies.

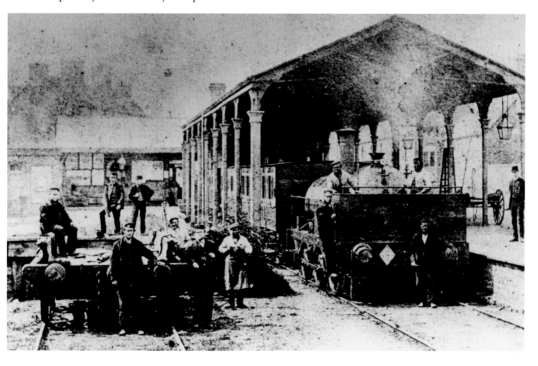

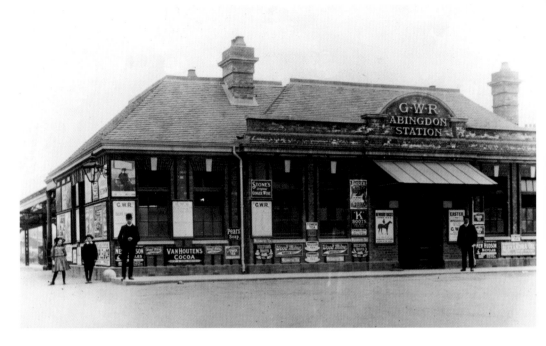

### The Railway Station

A railway accident at Abingdon on 22 April 1908. A goods train ran into a passenger train standing at the platform, telescoping the four passenger coaches. The coach nearest the station building was thrown over the buffers and crashed into the building. When the coach was removed the station roof collapsed. Fortunately no one was injured and the station was rebuilt and reopened within a year, as the 1910 photograph shows.

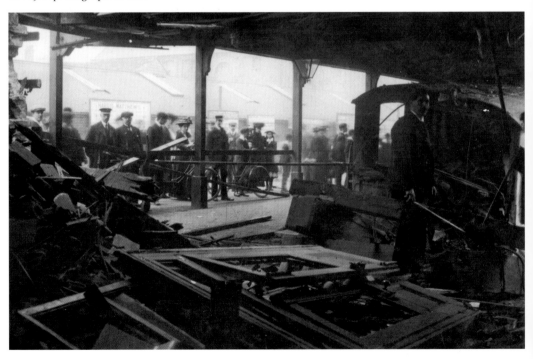

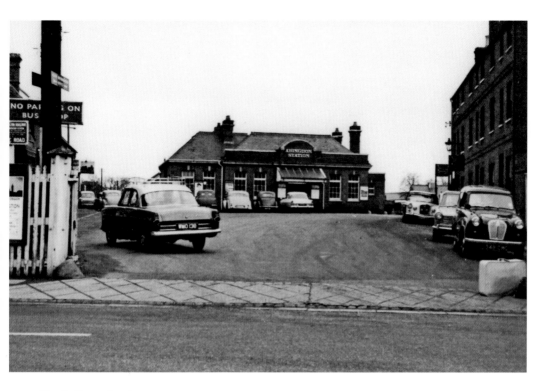

### The Railway Station

Abingdon railway station and Station Road in March 1963 and empty carriages arriving at the platform on 23 July 1963. Passenger traffic ceased the following September, although the station building remained intact for some years, being for a time converted into a Boys' Club.

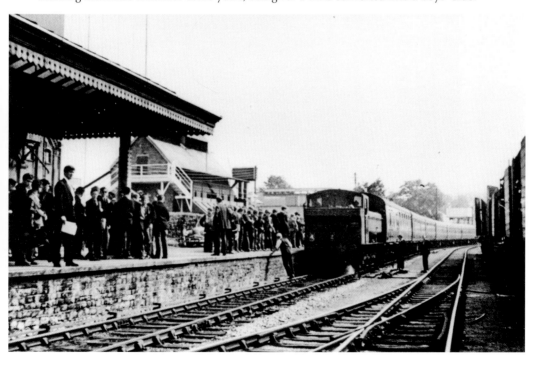

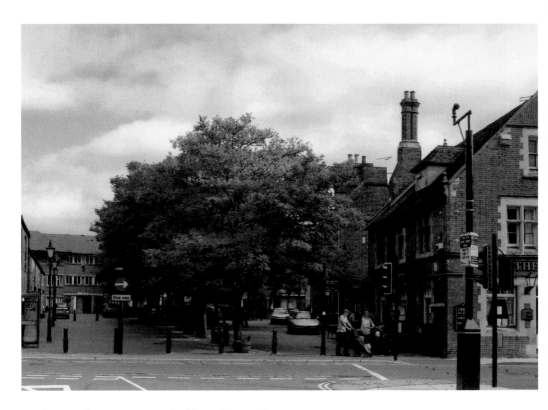

**Station Road, Later Renamed Old Station Yard**
The railway station was demolished on 6 May 1974, but the line continued to be used for coal and for conveying MG cars from the Abingdon factory until the end of the 1970s. By September 2009, Station Road, now renamed Old Station Yard, had been pedestrianised, from August 1993. At the bottom of the Yard is the Old Station House, a residential care home for the elderly, opened in 1996 on the site of the former railway station.

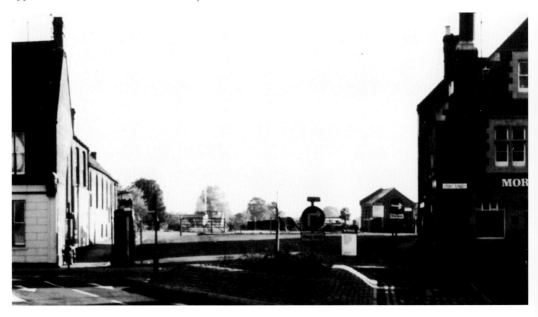

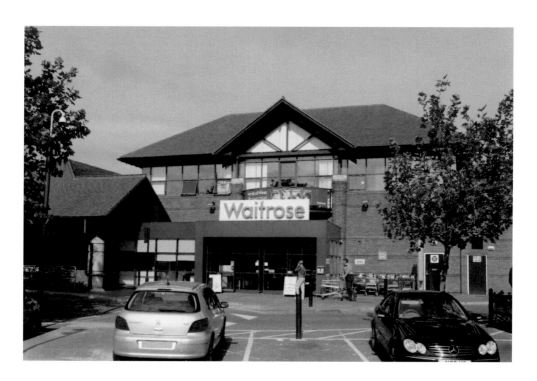

**The Site of the Former Railway Station**

Another view of the Old Station House residential care home in September 2009 and the Waitrose store in Abbey Close. It was built on the site of the former railway yard and was opened in March 1994. Its car park was laid out partly along the line of the former railway track.

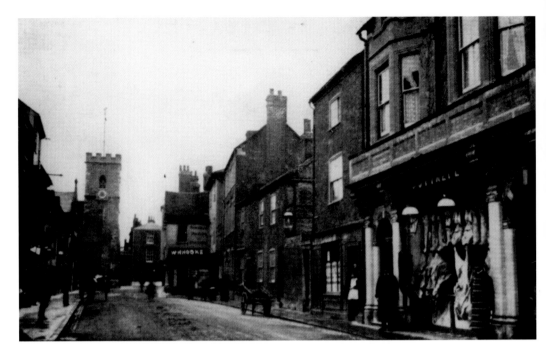

**Stert Street**

Stert Street, *c.* 1910, looking towards St Nicolas' church. Cottrell's butcher's shop on the right with its carcasses of meat hanging outside would not meet modern food hygiene standards. At the bottom of the street on the right is the shop of W. H. Hooke, printer and stationer. It extended through to the market place. An advertisement for J. E. Cottrell in the early twentieth century indicated the range of his products.

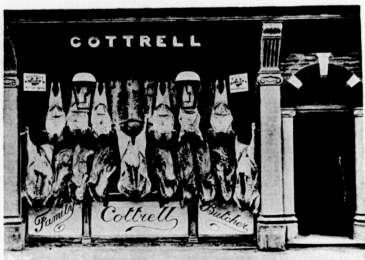

**Four Prize Medals against all England. London Dairy Shows, 1889, 1901, 1903.**

Specialities:

Well hung Saddles of Mutton.

Spiced Beef, Pickled Tongues, Mild Cured Bacon and Hams.

Bacon and Hams sent carriage paid to all parts.

Note the Address: **J. E. COTTRELL,** Stert Street, **ABINGDON-ON-THAMES**

## Stert Street

Stert Street in March 1979 showed several small businesses. In the centre, at No. 22, where Cottrell's had once been located, was Hedges butcher's shop. It presented a very different view of the meat trade from its exuberant predecessor, but by June 2006 No. 22 had changed hands and was now occupied by Nursery World. That remained the case in September 2009, by which time there was no butcher's shop in Stert Street. Hedges were in business in Queen Street, in premises to the rear of their old shop but with no shop frontage.

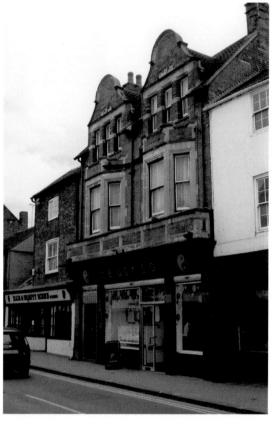

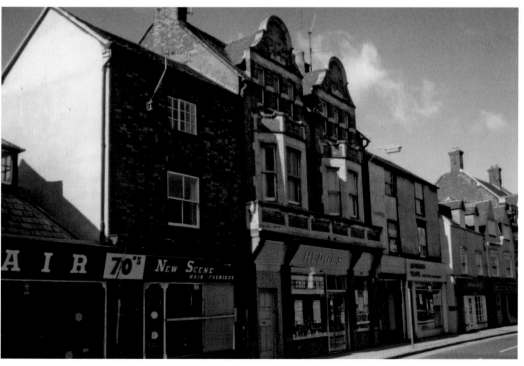

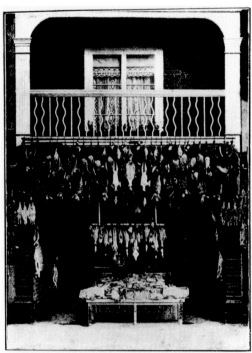

**T. A. RADBOURN,** Telephone 17.

**Fishmonger, Poulterer, & Ice Merchant.**

*Licensed Dealer in Game.*

**23, Stert Street, Abingdon-on-Thames.**

Prompt despatch of all orders in town and country.   Specialities of
any description.   Established over Half a Century

**Stert Street**

T. A. Radbourn of 23 Stert Street, *c.* 1920, unashamedly displayed his wares at the pavement's edge, regardless of possible health hazards from dust and flies. In April 2008, Nos 21 to 27 Stert Street were occupied by various businesses. Robert Stanley, opticians, occupied the shop which had once belonged to the fishmonger and poulterer, T. A. Radbourn.

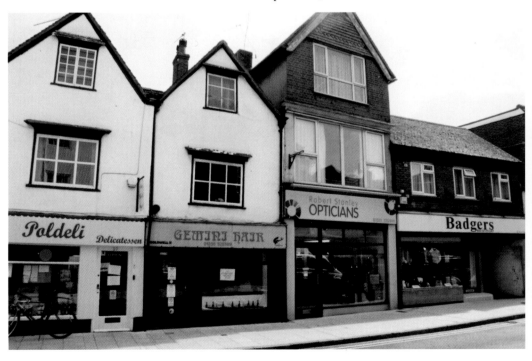

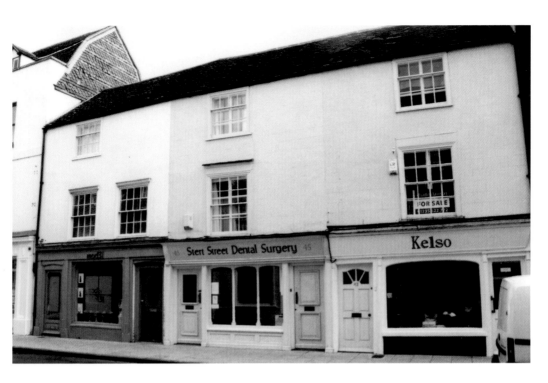

## Stert Street

Nos 43 to 47 Stert Street in March 1979, with the local office of the *Oxford Mail* located at No. 43. By April 2008 there had been a complete changeover in these shops. The Humble Pie, No. 45, had become a dental surgery and the *Oxford Mail* office, No. 43, had been replaced by Kelso fashion shop. It was indicative of the fluidity of shop ownership in Abingdon in the late twentieth and early twenty-first centuries.

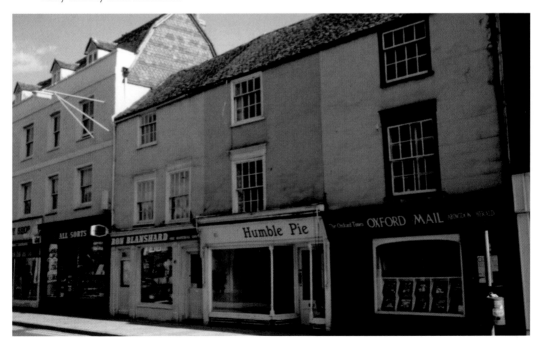

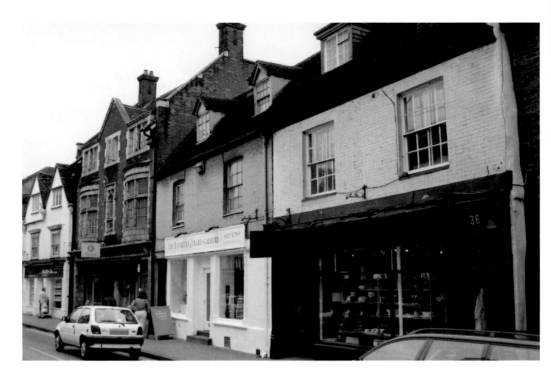

### Stert Street

The shop of R. S. Langford & Sons, corn and coal merchants, 32 Stert Street, with its elaborate frontage, dominates this photograph of Stert Street in March 1979. The space at the end of the block of shops, beside Togs, was used by Langford's for display purposes. By June 2006, however, Langford's former shop had been taken over by Oxfam and its neighbour, the Kitchen Centre, had become the Jennifer Gerard Gallery. The Togs shop was replaced by More Ingredients, selling food and cooking utensils.

### Stert Street

Ely Brothers, newsagents, stationers and tobacconists, sold a wide range of other products at their Stert Street shop, c. 1907. They had been in business since at least the mid-1890s and were agents for Sutton & Co., carriers. At No. 52 Stert Street was The Knowl, to the rear of which in March 1979 were the Hordeum maltings. The Knowl had been built in the seventeenth century and by the mid-1890s was occupied by John G. T. West, an architect and surveyor. The family remained in occupation in the early 1930s and Mr West himself had become a magistrate.

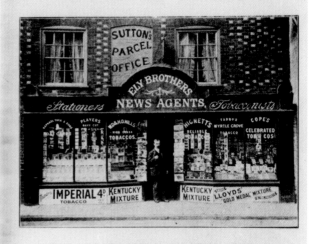

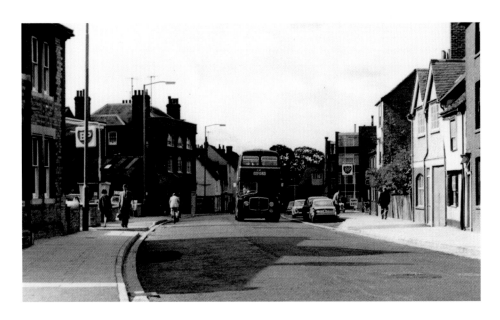

## Stert Street and The Vineyard

In February 2007, The Knowl was providing residential accommodation for adults. The maltings had been demolished and had been replaced by a large office block, part of The Charter complex. In September 2009, much of this was occupied by Oxfordshire Connexion, offering information, advice and guidance in apprenticeships, and interview practice and employment to young people aged sixteen to nineteen. The Vineyard, looking west in the early 1960s, had, at the bottom on the right-hand side, Banbury Court flats, which were handed over to tenants in the autumn of 1962 although Abingdon Borough Council expressed concern at 'the standard of workmanship' in them. They were subsequently refurbished. Nearly all the property on the left-hand side of the photograph was eventually demolished and replaced by houses and flats. That included the BP petrol filling station and the Red Lion public house. After being used as a temporary car park for some time, the garage site, together with land to the rear, was sold to Persimmon Homes in 2003 for the building of ninety houses and flats. The Red Lion public house closed in that same year.

**The Vineyard**

Some of the old properties in The Vineyard, including Ian Hayden's shop at No. 33, still survived in March 1979, but by June 2006 these earlier modest properties had been replaced. That included by a large modern office block at the bottom of The Vineyard. To the rear of the photograph, on the left-hand side, was the entrance to Abbey Close.

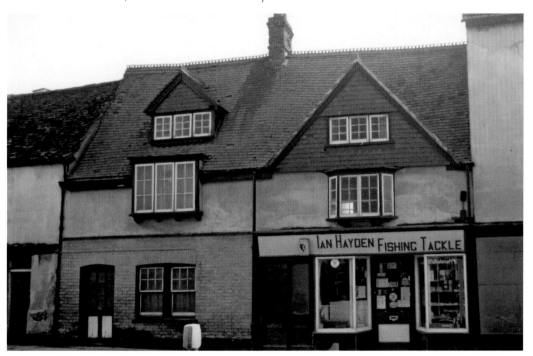

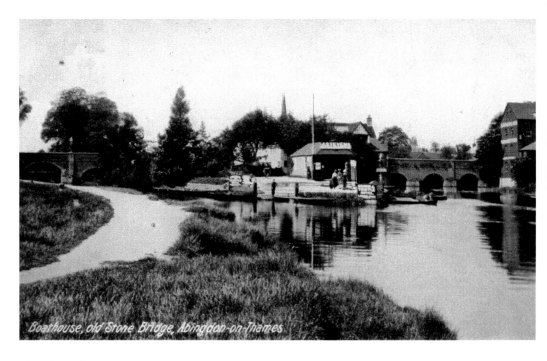

Boathouse, old Stone Bridge, Abingdon-on-Thames

## The River Thames

Peaceful scenes on the river Thames. In the *c.* 1910 view a pleasure steamer can be seen and, in the background, the graceful spire of St Helen's church. On the right, behind the trees, was the roof of the Old Gaol. In the centre of the *c.* 1895 photograph can be seen Stevens' boathouse. At this time James Stevens advertised himself as a boat, punt and canoe builder. On the right was the Abingdon Carpet Factory, which had formerly been a hemp and twine works.

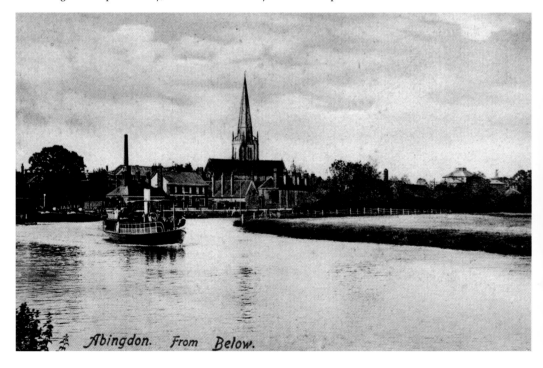

Abingdon. From Below.

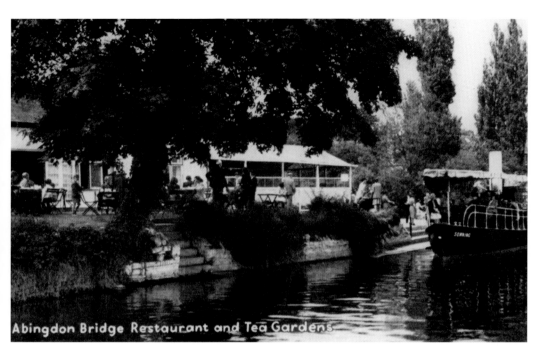

Abingdon Bridge Restaurant and Tea Gardens

## The River Thames

Boating on the River Thames *c.* 1900. The boats were probably hired from Stevens' yard, to the rear of the photograph. Half a century later, one of Salter's pleasure steamers, *The Sonning*, was moored alongside the Abingdon Bridge Restaurant and Tea Gardens on Nag's Head Island. The restaurant was later destroyed by fire, but new facilities were provided and Salter's pleasure steamers continue to call during the summer months.

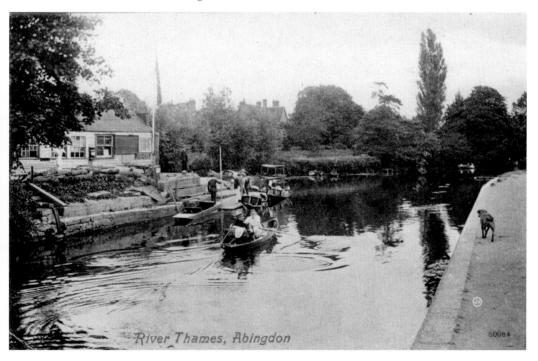

River Thames, Abingdon

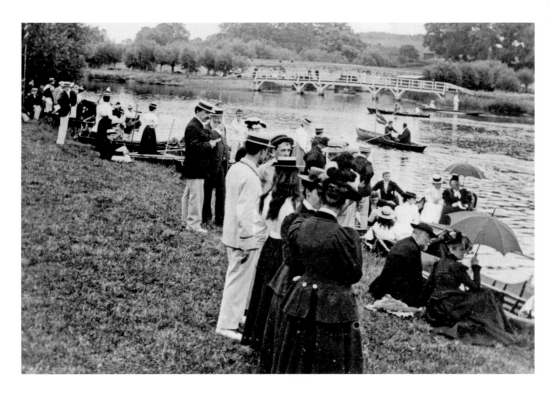

## The River Thames

The River Thames was the scene of regattas, in this case involving boys from Abingdon School and a group of family and friends *c.* 1900. Also *c.* 1900, a mother and her children were standing on the bridge outside the Nag's Head public house. It was a very different picture from the traffic situation a century later. In the 1890s Joseph Reynolds, the landlord of the Nag's Head, also advertised himself as a basket manufacturer.

The Bridge, Abingdon. 509

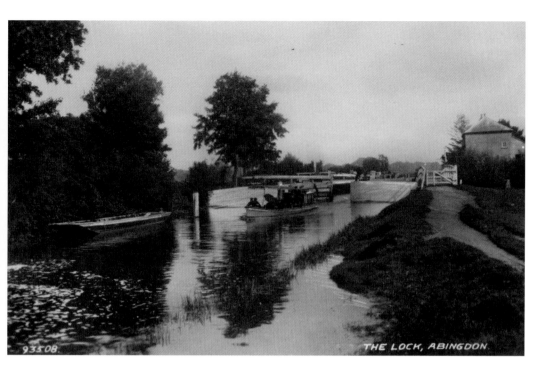

### Abingdon Lock

Abingdon lock, with a pleasure craft emerging, *c.* 1900. In 1999/2000 Abingdon lock had to have a set of lock gates installed.

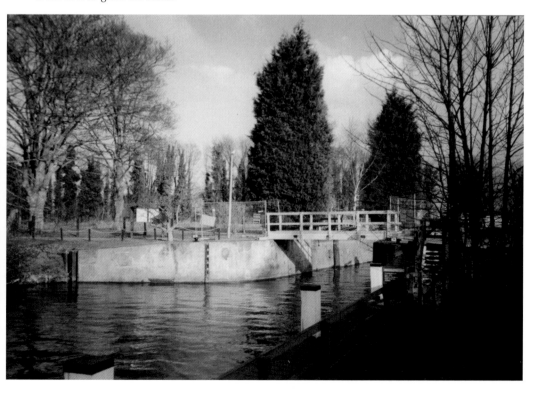

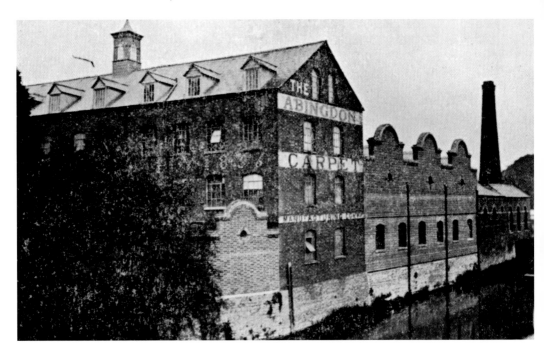

## Thames Wharf

The Abingdon Carpet Factory *c.* 1920 and workers in the factory *c.* 1900. The firm was established by the Shepherd Brothers, carpet, rug and matting manufacturers, and it was closed as a result of foreign competition, particularly from Germany, in the early 1930s. The property was purchased by Abingdon Borough Council in the mid-1930s, and in the 1950s it was considered as the possible location of a swimming bath. In 1953, the premises were occupied by the Longworth Scientific Instrument Company and when they left in the late 1950s various schemes were considered for its use. The factory was demolished after a fire in 1961 and eventually it was sold in 1967 to the builders of the Upper Reaches Restaurant and car park.

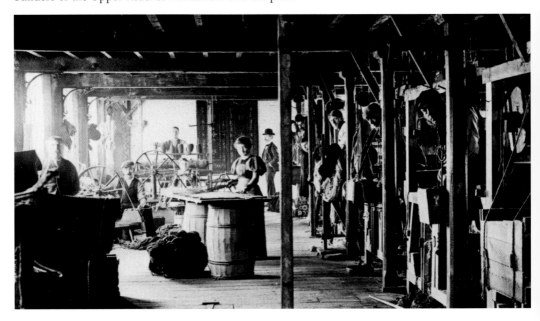

## Thames Street

The Upper Reaches Restaurant, car park and landing stage, on the site of the former Abingdon Carpet Factory, *c.* 2005 and Thames Street and the Abbey Mill *c.* 1911. The mill was run by R. S. Langford & Sons, corn and coal merchants, and as late as the 1960s flour and animal feed were being produced there. In 1969, Trust House Hotels acquired the Abbey Mill from the lessees and the mill building was then incorporated into the new Upper Reaches Hotel.

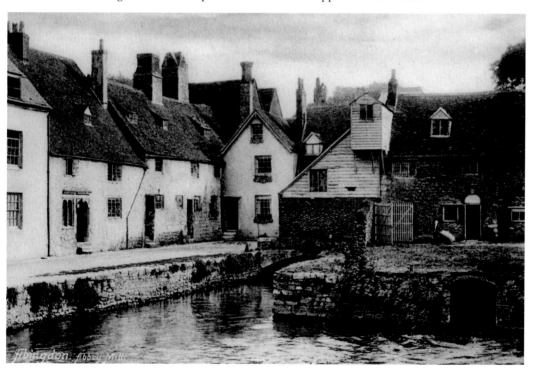

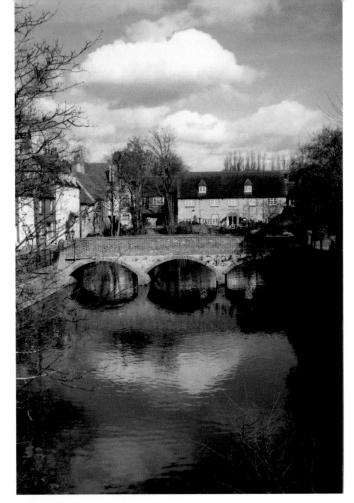

**Thames Street**
Two views from Abingdon bridge of the Upper Reaches Hotel, with the converted Abbey mill building, *c.* 2005. The mill yard was laid out as a garden, and the bridge had been renovated. The Upper Reaches Restaurant is visible through the trees on the right of the second photograph. The block of flats on the near left in Thames Street was built as a result of a slum clearance programme in the 1950s and other buildings have been renovated.

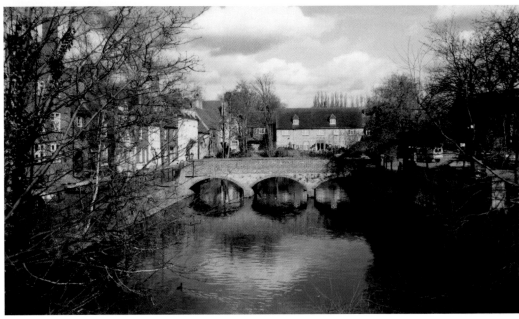

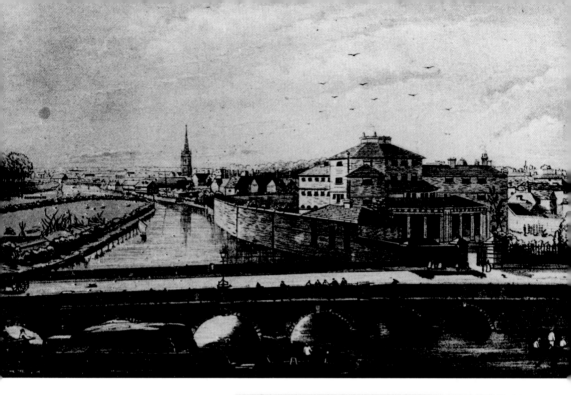

## Thames Street and the River Thames

Old houses in Thames Street *c.* 1920 in need of renovation. In the background is the thirteenth-century Abbey Chimney and on the right is the bridge to the Abbey Mill. The wider view of Abingdon from the river Thames in 1858 shows the County Gaol dominating the scene on the right. It was built in 1811 and was intended to house prisoners brought in from Reading for Abingdon's Summer Assizes, as well as local prisoners. It was closed in 1868 when the Berkshire magistrates decided its accommodation was unsuitable and that it was an unnecessary expense. The Summer Assizes in Abingdon ceased soon after. The gaol was then sold and was subsequently used for many years as a grain store by Charles Woodbridge, saddler, harness maker and corn, seed and hay merchant.

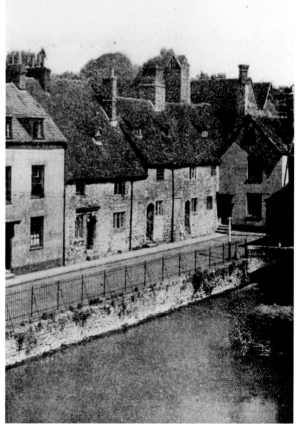

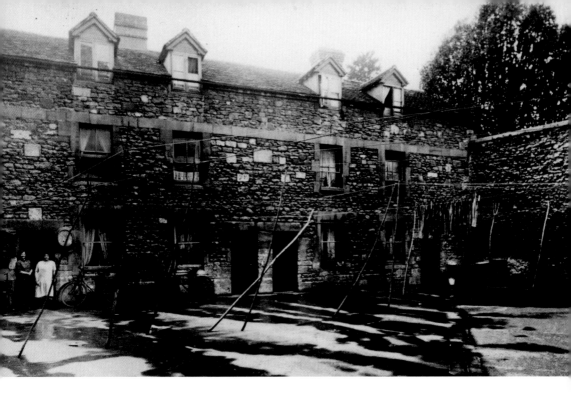

### The County Gaol and Bridge Street

Ancillary buildings in the Old Gaol yard were turned into tenements and were still being occupied in 1949 when the photograph was taken, although as early as 1935 properties in the gaol yard were condemned as 'unfit for human habitation.' The earlier view shows Bridge Street looking north *c*. 1880s. On the right was the Broad Face public house, with the Crown and Thistle hotel further along the street. On the left was Woodbridge's corn merchant's and saddler's shop, built in 1880 across the Old Gaol's forecourt. On the near left is the entrance to the former County Gaol itself.

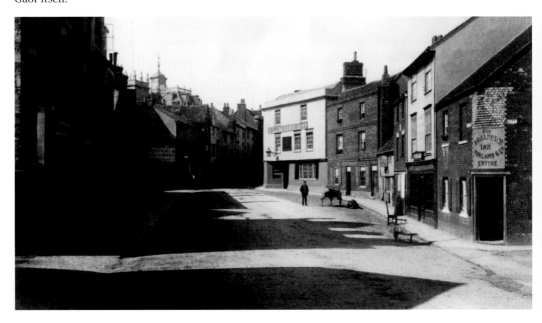

### The Former County Gaol

The Old Gaol was undergoing renovation in August 1974, after it had been purchased by Abingdon Borough Council in the previous year in order to preserve it. In the 1970s, it became a leisure centre, but at the beginning of the twenty-first century it was closed. In September 2009, it remains unoccupied. It has been sold to a property company but as yet no development has taken place. At one time in the early twenty-first century it was considered a possible site for the Abingdon museum but that proposal was dismissed on cost grounds.

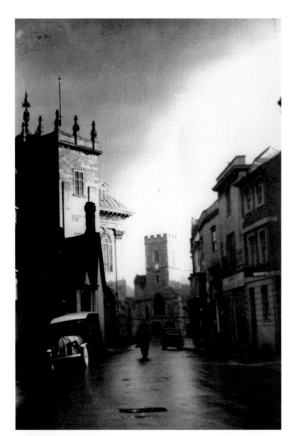

**Bridge Street and East St Helen Street**
The courtyard of the Crown and Thistle Hotel, an old coaching inn in Bridge Street, *c.* 1917. Around thirty years later, there is an almost traffic-free East St Helen Street. St Nicolas' church is in the background and the County Hall is just visible behind the Punch Bowl public house on the left.

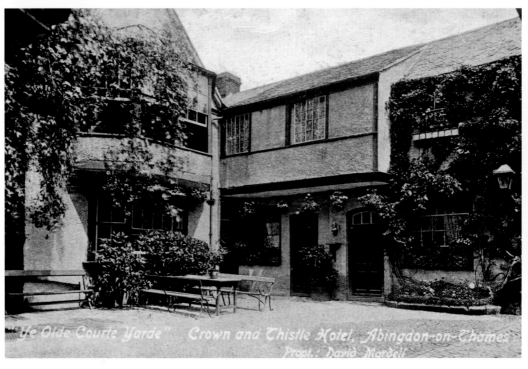

*"Ye Olde Courte Yarde" Crown and Thistle Hotel, Abingdon-on-Thames*
*Propr.: David Mardell*

### St Helen's Wharf

Brick Alley almshouse in St Helen's Wharf during the 1960s. It was rebuilt between 1718 and 1720 for eighteen men and women. A broader view of St Helen's Wharf is provided in the *c.* 1910 photograph of a couple boating on the river Thames.

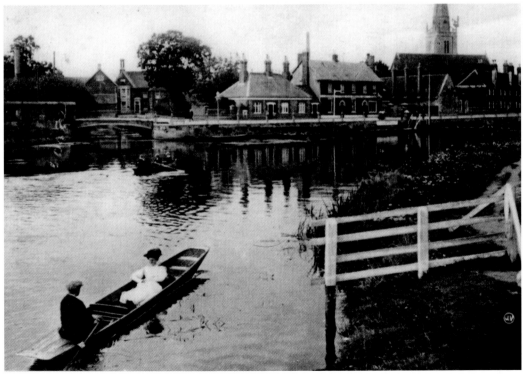

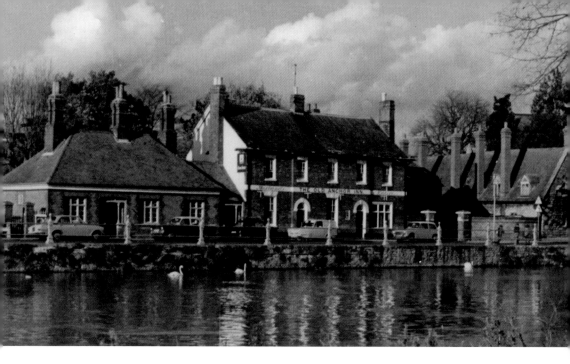

## St Helen's Wharf

The Old Anchor Inn is in the centre of this tranquil view of St Helen's Wharf in the 1960s. On the right is the roof of the Long Alley almshouse. When river traffic was important in the nineteenth century the Old Anchor benefited from its proximity to the Thames and to the Wilts and Berks canal. In 1884, it was rebuilt in its current position, on the other side of the road away from the river's edge. By September 2009, little had changed in St Helen's Wharf compared to forty years earlier except that a few pleasure boats were now moored on the river.

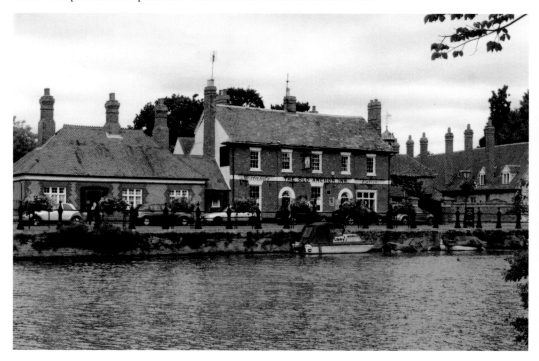

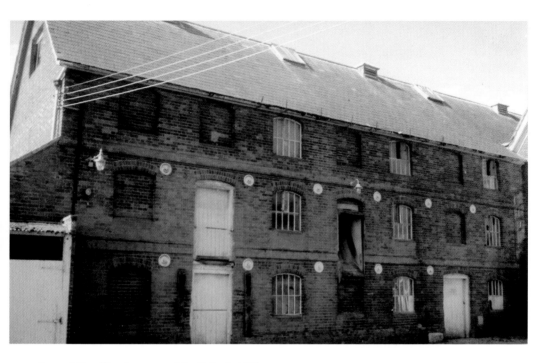

### Long Alley Almshouse and St Helen's Mill

In 2009, there is little external change in the Long Alley Alms House compared to the 1930s. This is Abingdon's oldest Alms House, being erected in 1446. For centuries the master and governors of Christ's Hospital have met in its hall. Near at hand is St Helen's Mill. In March 1979, this derelict warehouse belonged to the St Helen's Milling Company, which supplied animal feed. As early as 1972, Abingdon Borough Council had agreed to a change of use to provide housing and office accommodation.

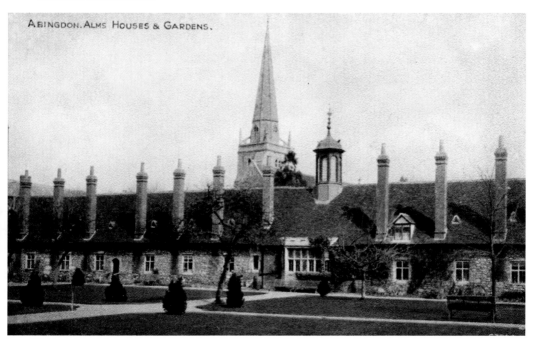

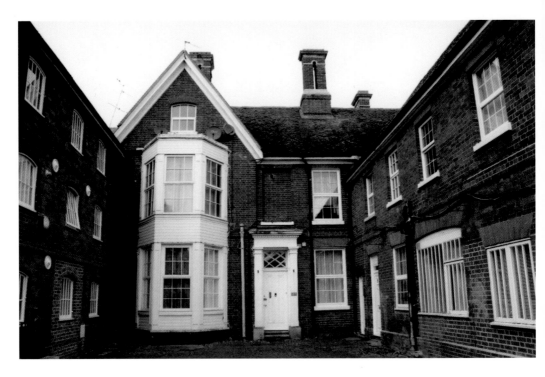

## St Helen's Mill

The renovated St Helen's Mill warehouse in June 2006. It was converted into private housing at the beginning of the 1980s. St Helen's Mill House itself continued in the occupation of the St Helen's Milling Company until the 1990s, and then it too was converted into private accommodation. The photograph shows St Helen's Mill House and the renovated ancillary buildings in February 2007.

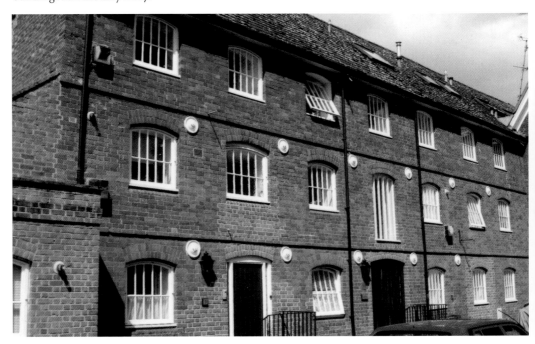

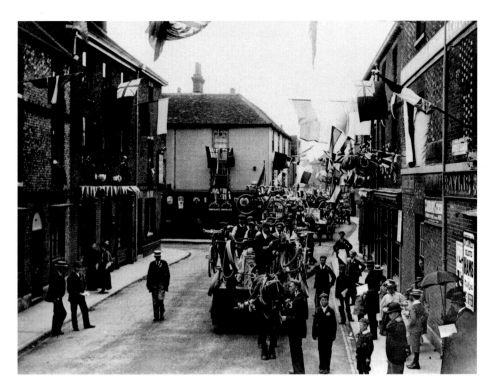

### West St Helen Street

The procession of floats in West St Helen Street in 1897 was to celebrate Queen Victoria's diamond jubilee. The procession was heading towards the High Street. On the right was Baylis's High Street grocery shop and in the background, on the left, was W. Brewer's fruit shop, which also advertised Cadbury's chocolate, at 22 Lombard Street and 8 West St Helen Street. The same view of West St Helen Street in September 2009 showed some of the considerable rebuilding and renovation that had taken place both in West St Helen Street and Lombard Street.

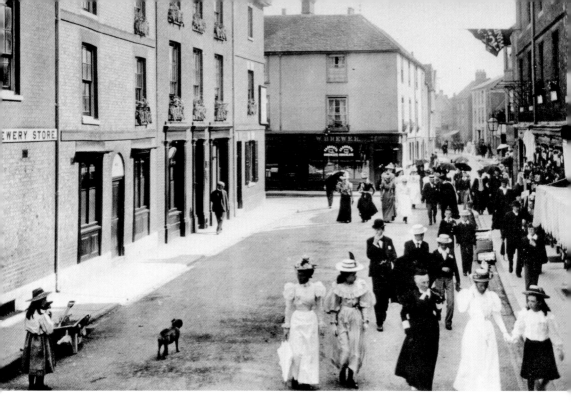

### West St Helen Street

Another view of West St Helen Street *c.* 1900, this time commemorating Abingdon School's Founder's Day, with parents, friends and some of the boys walking towards the High Street. Much rebuilding and renovation of property, mainly for residential purposes, took place in West St Helen Street during the late twentieth and early twenty-first centuries. On the left in July 1979 are boarded-up houses awaiting redevelopment. At the bottom of the street is St Helen's church, with its slender spire. On the right are town houses, built in the early 1970s.

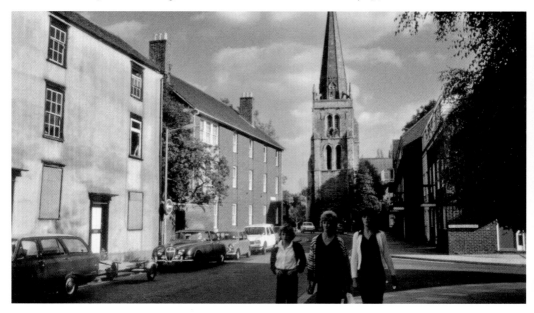

### West St Helen Street

The boarded-up dwellings shown in the 1979 photograph in West St Helen Street had been replaced by attractive modern houses by March 2007. Meanwhile, premises at the upper end of West St Helen Street, near the High Street, in 1979 included the Glendale Electrical Services shop, an estate agent's and Hadleigh's china shop at the corner with the High Street, where Baylis' grocery store had once been.

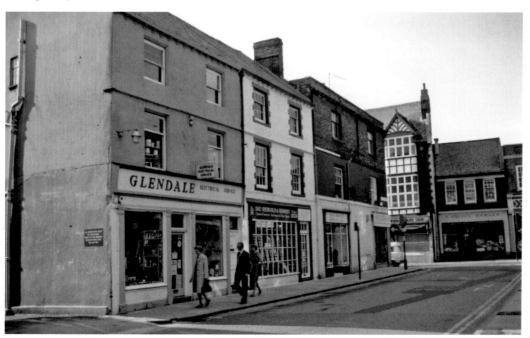

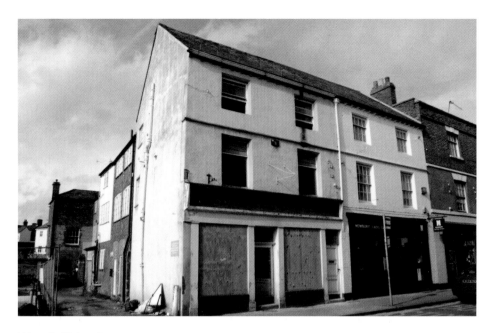

## West St Helen Street

In the early twenty-first century the competition of the large chain stores was driving some of the smaller Abingdon shops out of business. By February 2007 the Newbury Building Society had replaced the estate agent's and Glendale electrical shop had closed in the autumn of 2006 after more than half a century. Paul and Terry Heast, who ran the business founded by their father, blamed 'competition from shops on the Fairacres retail park such as Homebase, B & Q and Argos' for the closure, as well as the nearby Tesco superstore, which also sold electrical goods. By August 2009, Frend & Co., jewellers, had taken over the former Glendale shop and the Thai Orchid Oriental Supermarket had replaced Hadleigh's china shop. The Newbury Building Society remained and between it and the supermarket was a small shoe shop, which had also featured in the February 2007 photograph.

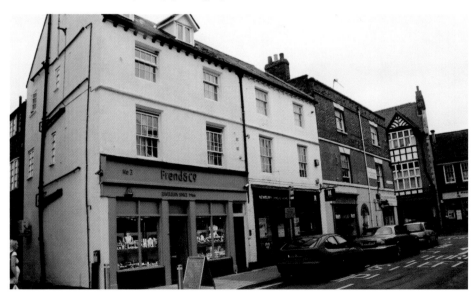

## Lombard Street
No. 6 Lombard Street, a boarded up, semi-derelict property formerly occupied by a furniture dealer and house clearer, awaited renovation in the late 1970s. By June 2006, that had been accomplished. No. 6 was now an attractive residence.

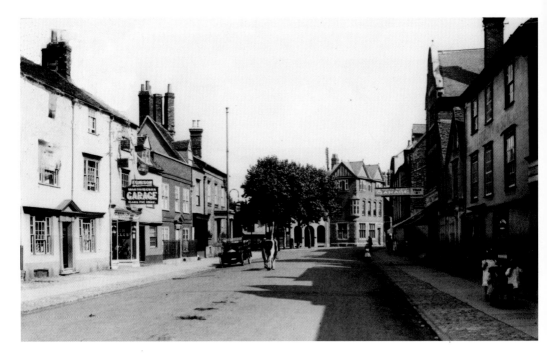

## Ock Street

Ock Street looking west *c.* 1890, with the Congregational church in The Square on the right. To the left are several tradesmen's delivery carts, evoking the leisurely spirit of the age. The 1915 photograph of Ock Street looks east towards The Square. The horse and carter walking along the road suggest the still leisurely pace of life in the town, although the board advertising F. Gibson's North Berks Garage, on the left, with its mention of cars for hire was an indication of things to come.

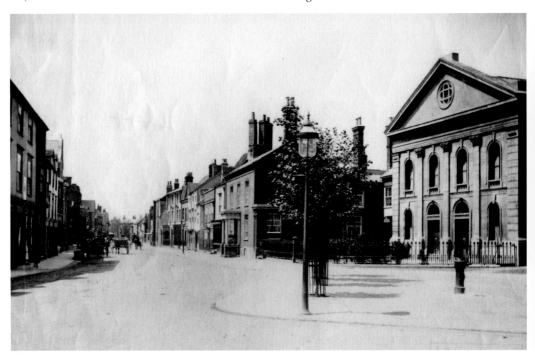

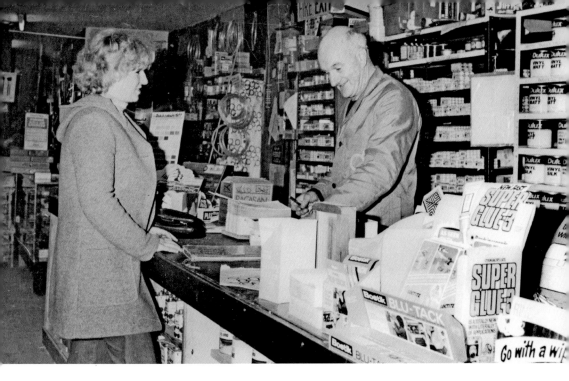

### Ock Street and the Beadles Family

Beadles, the Ironmongers and Locksmiths, at No. 30 Ock Street in August 1979. Bertram Beadle had come from Sussex after the First World War and became an assistant at the Brind, Gillingham Hardware Store, Ock Street, in 1919. After a change of ownership in 1939, Mr Beadle, now the store manager, purchased the business with his wife in 1951. Following his death in 1965, his sons ran the shop. It was much valued by customers for its wide range of stock and good personal service. The 1978 photograph of the interior of Beadle's shop shows some of the goods sold. A member of the family is serving a customer.

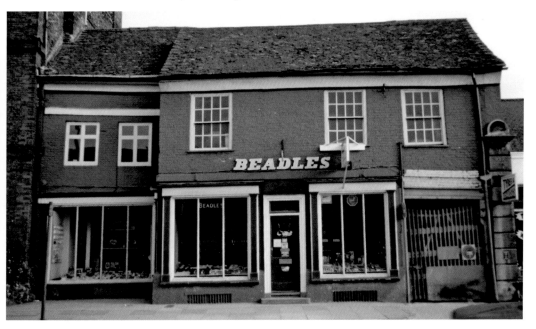

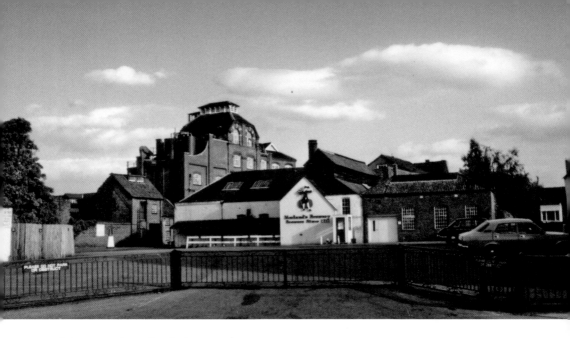

## Ock Street and Morland's Brewery

On 18 August 2001, the Beadle family shut up shop for the last time. The old-style business had fallen victim to the competition of larger rivals and to property developers, who were building on the former Morland brewery site to the rear. The Beadle shop was also developed for housing but it was a condition of the redevelopment that the façade of the former shop be preserved and the August 2009 photograph shows that this was done. Behind Beadle's shop was Morland's Brewery, which in August 1989 was still flourishing. The Morland family had begun brewing at West Ilsley in 1711, but in 1861 Edward Morland purchased the Eagle Brewery in Ock Street and five years later took over the Abbey Brewery. In 1999, Morland & Co. was taken over by Greene King, an East Anglian brewery. Closure of the Ock Street site followed in February 2000. At the time of the takeover Morland's owned 123 managed public houses and 285 tenanted pubs, mostly in the Thames Valley. In Abingdon itself a number of the pubs were closed and sold for housing development.

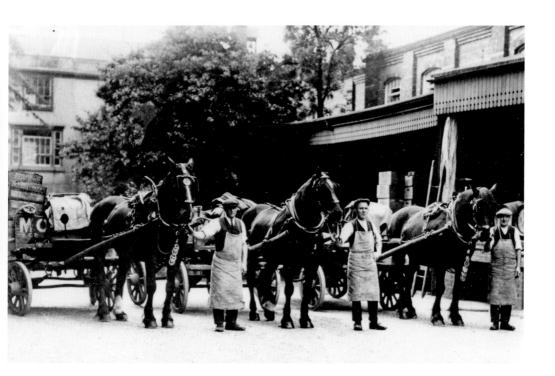

## Morland's Brewery, Ock Street

A group of mid-Victorian coopers employed by Morland's on the Ock Street site. A five-year apprenticeship had to be served, but in 1960 the production of wooden casks ceased when metal casks were substituted. In October 1936, horses were still used, as the photograph outside the brewery cart shed confirms.

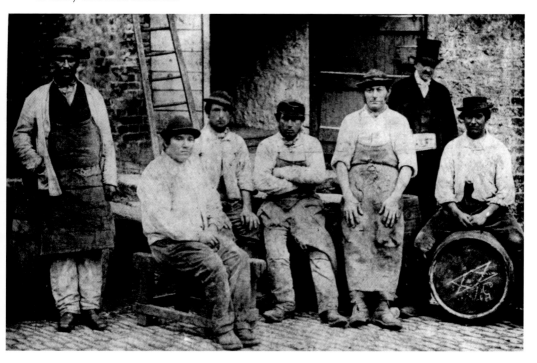

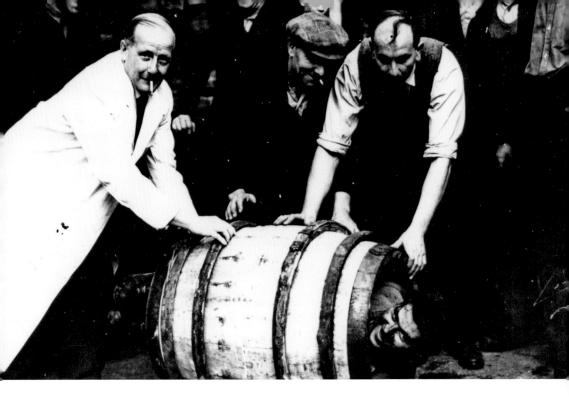

**Morland's Brewery, Ock Street**

An apprentice cooper undergoing a traditional initiation ceremony at the brewery after the Second World War. Over the years, more than one generation of the same family worked at Morland's. However, in 2000 approval was given for the redevelopment of the brewery site for houses and flats. The whole development was to be known as The Brewery and Berkeley Homes were to provide 150 dwellings. Reminders of the past were given in the street names, such as Drayman's Walk, Brewers Court and, as in this June 2006 photograph, Coopers Lane.

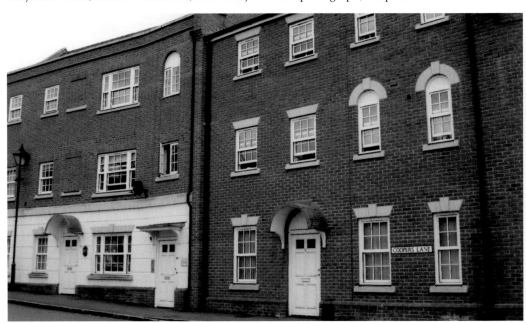

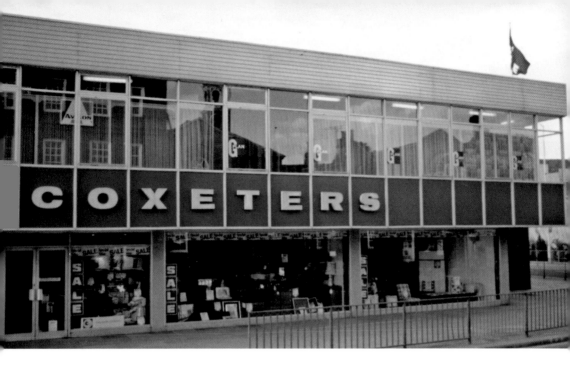

## Ock Street

Another view of Coopers Lane on the redeveloped Morland site in August 2009 and Coxeters' modern department store in Ock Street in August 1979. Charles Coxeter came to Abingdon in 1820 to work in a drapery shop. In 1836, he opened a hardware store at No. 30 Ock Street and subsequently acquired other properties, where bicycles, motor cycles, cars and furniture were sold. In 1912, the firm advertised as 'House Furnishers, Decorators, Undertakers, Bedding Specialists', with 'Furniture removed and warehoused'. At that date it was located at Nos 21 to 27 and No. 48 Ock Street.

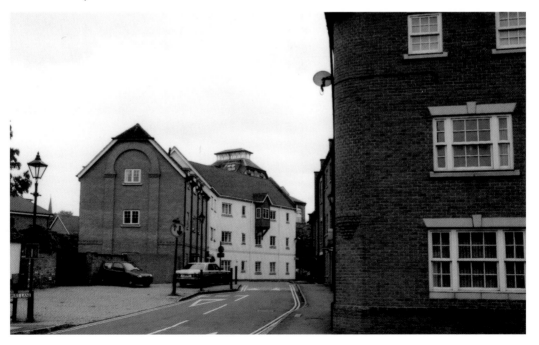

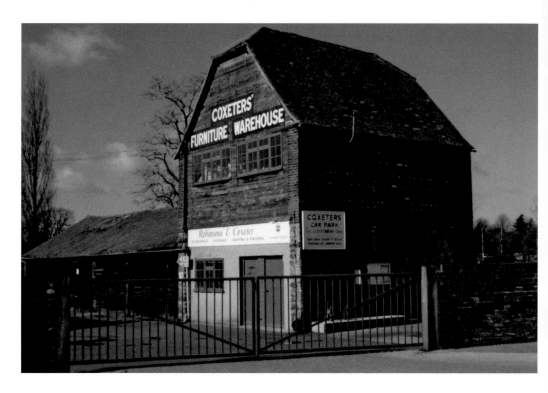

### Coxeters and Ock Street

Two views of Coxeters' furniture warehouse and customers' car park, March 1979. An old-style petrol pump at the side bears a warning notice: 'Petroleum Spirit, Highly Inflammable, No Smoking, Switch Off Engine'. Its location by a furniture warehouse would hardly seem ideal!

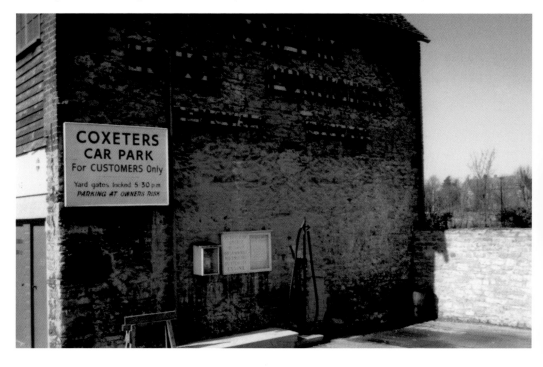

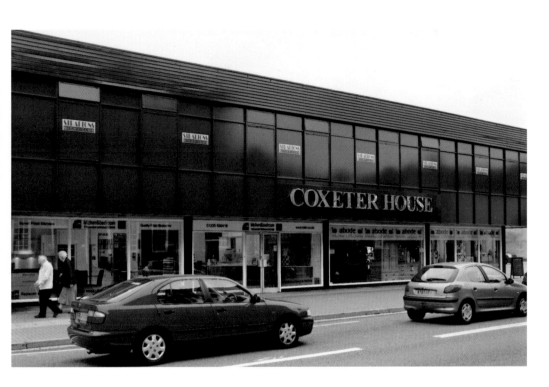

## Coxeters and Ock Street

A view of one of Coxeters' barns in March 1979. However, in 1984 Coxeters ceased to trade as a shop and became a property company. As this August 2009 photograph shows, the shop was then known as Coxeter House and accommodated a number of independent businesses. On the upper floor is Stratton's Night Club.

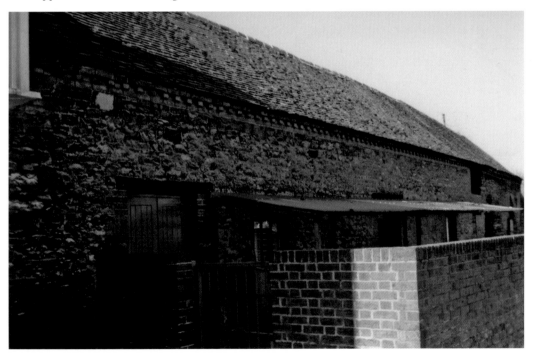

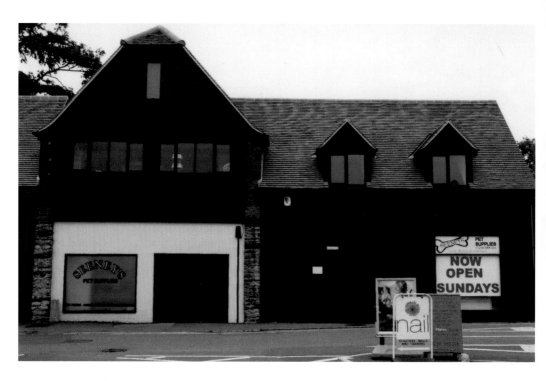

## Coxeters and Ock Street

Some of the former outbuildings on the Coxeter site have been redeveloped for other uses. In August 2009, one building was devoted to Seeney's Pet Supplies and part of another had become a snooker and pool hall.

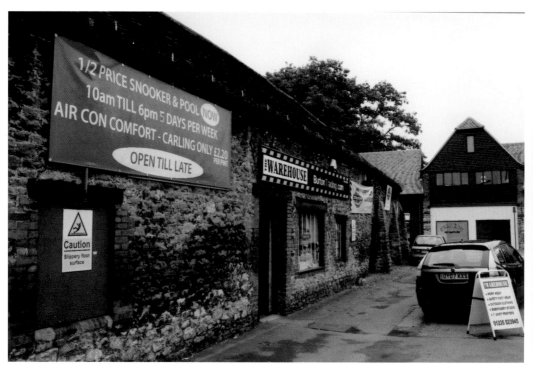

### Ock Street

Enock's coal yard in August 1979. William Enock moved to 75 Ock Street in the early 1890s and started a business as a coal and wood merchant, using an adjacent yard for storage and carting his coal from St Helen's Wharf. Later, in the early twentieth century, he became a jobmaster too, hiring out carts and carriages. The family remained in business to the end of the twentieth century but then the coal yard was sold for housing. By August 2009, it had become a housing complex called Ock Mews. The spire of Trinity church in Conduit Road can be seen in the background.

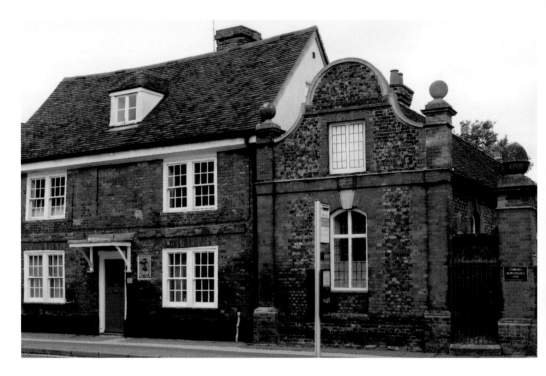

## Ock Street

The Crown Public House, No. 83 Ock Street, and Tomkins' Almshouses in August 1979. By August 2009, The Crown, a former Morland public house, had become part of the Crown Mews, a private residential development built in 1995. Morland's logo, depicting an artist, still remained on the wall, however, as a reminder of its past. The brewery had chosen the logo many years before to commemorate the family's connection with the well-known artist George Morland (1763-1804).

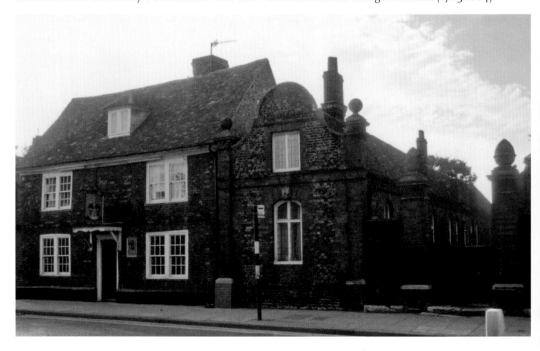

## Ock Street

Mr Warrick's Arms in August 1979. This was another Morland public house and had been trading since 1854, seven years before the brewery itself came to Abingdon. By 1979, however, it was looking shabby. It was near to the Crown Public House and by September 2006 had undergone a radical change in appearance. It was no longer a public house but had become part of the Crown Mews housing development.

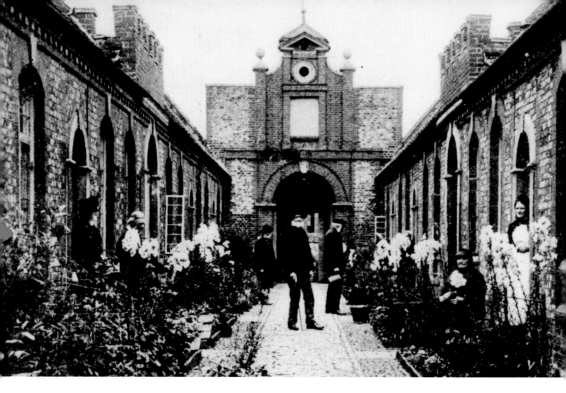

## Ock Street

Tomkins' Almshouses in Ock Street *c.* 1907, pictured with some of the residents. The Almshouses were founded in 1733 under the terms of the will of Benjamin Tomkins, a wealthy maltster. It was for the Baptist community and provided for four male and four female residents. In 1987, the property was conveyed to Abingdon's major charitable body, Christ's Hospital. Further along Ock Street, at No. 169, was the Air Balloon public house with Blake Bros, corn merchant's business, beside it, pictured in August 1979. The Air Balloon, probably an old coaching inn, was first mentioned in 1788 and its stables can be seen on the right. From the 1880s to the early twentieth century, the Aldworth family apparently ran an agricultural implement maker's enterprise in its yard. In the late nineteenth century, the Blake Bros' property had also been a public house, it was called The Holly Bush.

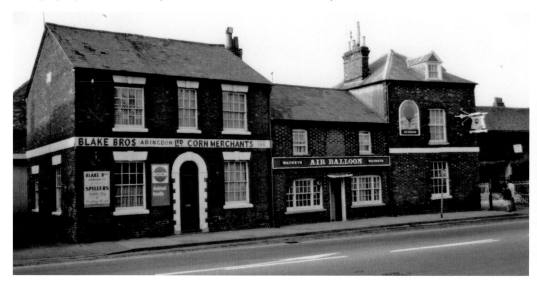

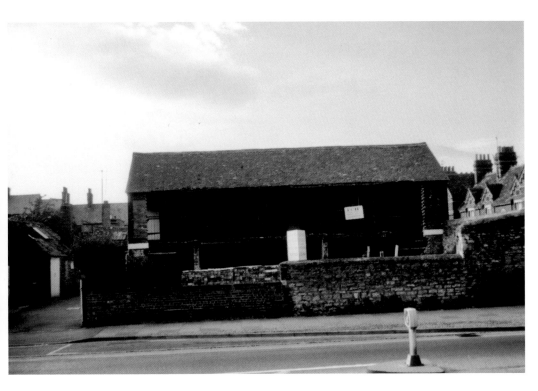

**Ock Street**
The stables and yard attached to the Air Balloon in August 1979. The more detailed second photograph shows that by that date the stables were semi-derelict.

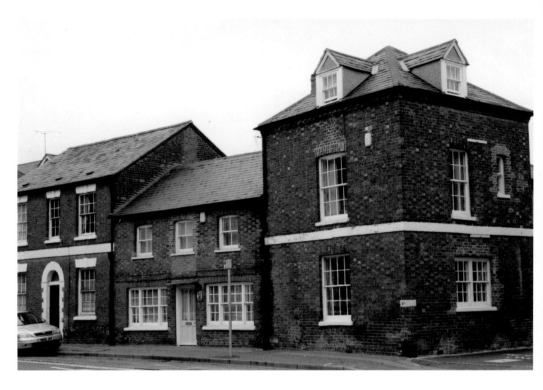

**Ock Street**
By August 2009, the Air Balloon itself had been turned into private housing and Wisteria House apartments were built on the site of the former yard and stables.

## Ock Street

By September 2006, the Blake Bros were no longer in business and their property had become a private house. As a reminder of its past, however, a faint notice on the front wall advertised fertilizers and farm seeds, and cattle, poultry, dog and bird foods. That was still visible in September 2009. Further down Ock Street in August 1979 these tenements were still occupied. In the brickwork can be seen the date, 1863, when they were built. They were demolished in the 1980s.

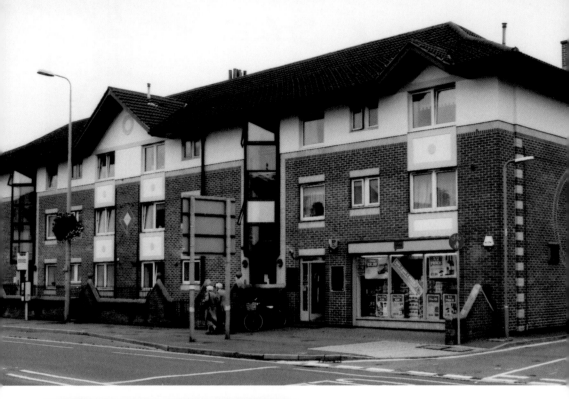

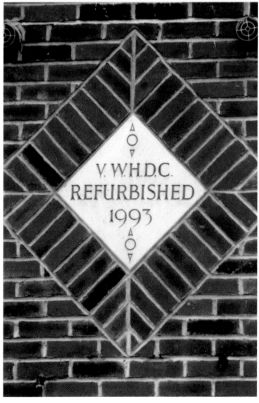

V. W.H.D.C.
REFURBISHED
1993

### Ock Street

These flats, photographed in August 2009, had replaced another tenement block known as 'Pig Row'. It ran from Nos 210 to 238 Ock Street and was so labelled because many of the residents kept pigs in their long back gardens. In June 1960, Abingdon Borough Council agreed to demolish 'Pig Row' as it was 'unsuitable for human habitation'. Council flats replaced the houses in the 1960s but twenty years later they were looking shabby. The Vale of White Horse District Council undertook a major refurbishment in the early 1990s and the plaque was installed at that time. At the end of the block of flats is an off-licence shop.

## Albert Park and Park Road

Statue of Prince Albert, Queen Victoria's consort, in the pleasant surroundings of Albert Park, with its lawns, shrubberies and network of paths. It is also the home of the Abingdon Bowls Club. The park was presented by the governors of Christ's Hospital in the early 1860s and the statue, bearing the date 1864 on its lofty plinth, commemorated the Prince, who had died in December 1861. Christ's Hospital was also responsible for the Victorian and Edwardian housing erected in the neighbourhood of the Park. These substantial middle-class houses, shown in the lower photograph, were located in Park Road *c.* 1920.

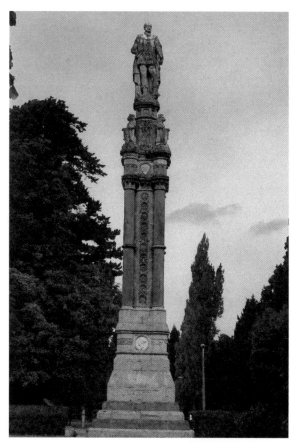

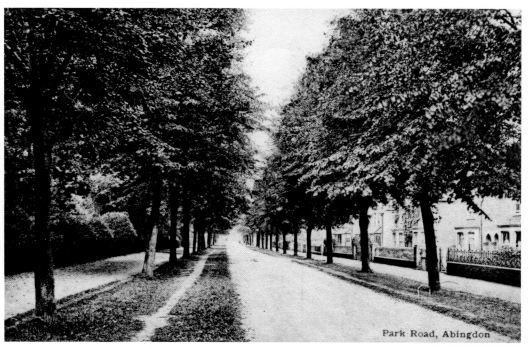

Park Road, Abingdon

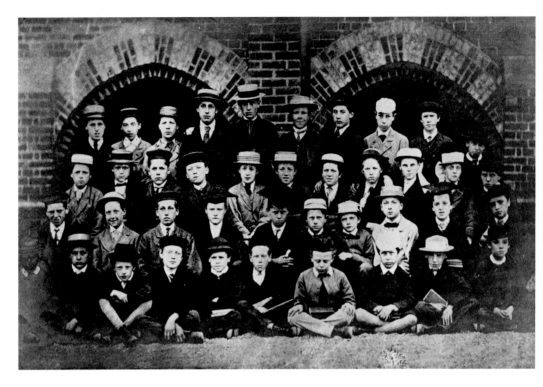

**Abingdon School off Park Road**

Abingdon School *c.* 1930, on the site near to Albert Park to which it had moved in 1870. The boys were pupils at Abingdon School in 1874, soon after the move. In these early years it was often known as Roysse's School, after its founder.

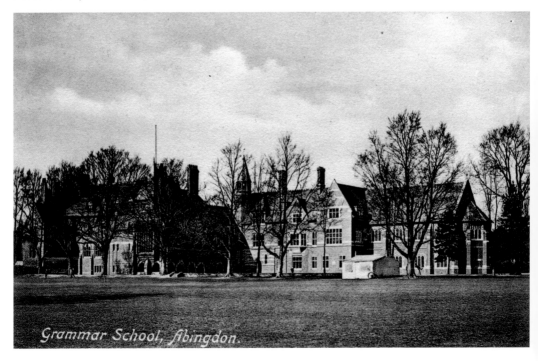

Grammar School, Abingdon.

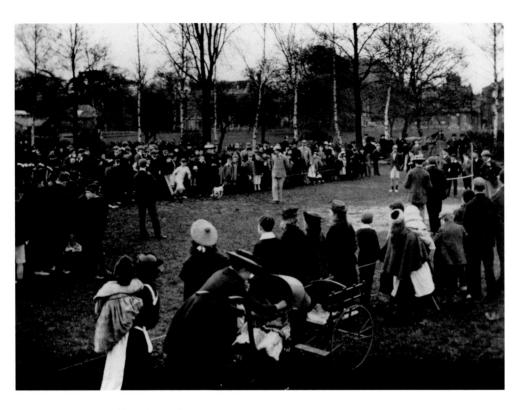

**Abingdon School off Park Road**
Sports day at Abingdon School in 1894, with an admiring group of onlookers, and the now very much expanded Abingdon School in September 2009.

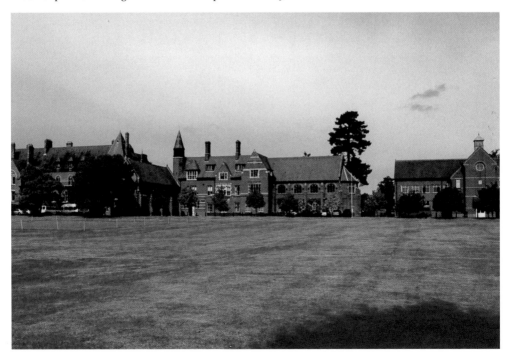

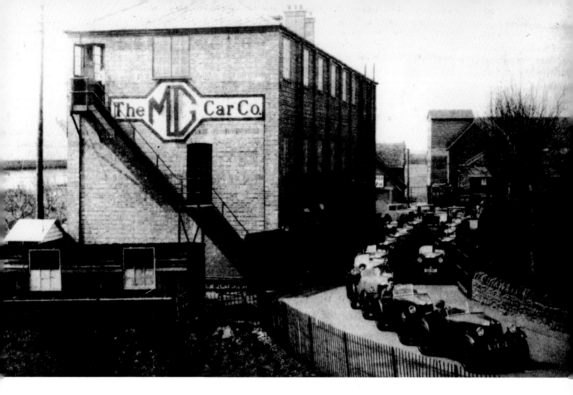

### Spring Road and the MG Car Factory

A procession of MG cars moving down Cemetery Road in 1929. The MG Car Company had moved from Oxford in that year to the Spring Road site of the Pavlova Leather Company in Abingdon. It occupied part of the factory and the old Pavlova office block on the left of the photograph. The buildings to the rear on the right were still in use by Pavlova tannery. The first Abingdon-produced MG Car rolled off the production line in mid-January 1930. The production line, as it existed in the 1930s, is shown in the photograph. The last Abingdon-made MG left the production line on 23 October 1980. The factory closed the following day.

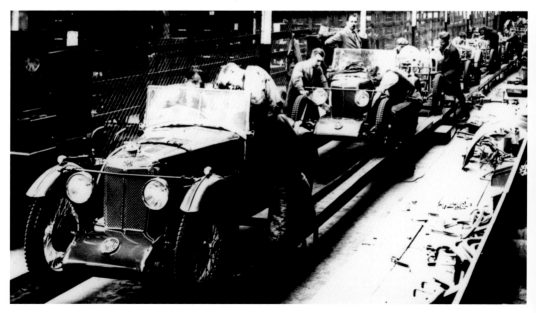

84

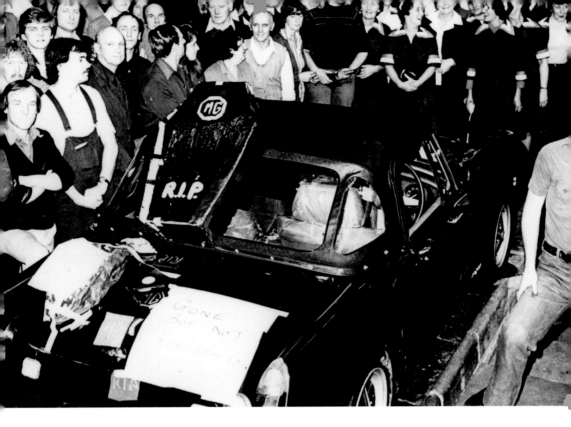

## MG Car Factory, Spring Road and Marcham Road

The last MG car to leave the Abingdon production line on 23 October 1980 was given a mock funeral. A handwritten notice on the car's bonnet read 'Gone but not forgotten'. The factory was closed as part of a reorganisation strategy by the parent company, British Leyland. Demolition soon began and the second photograph shows the situation in September 1981.

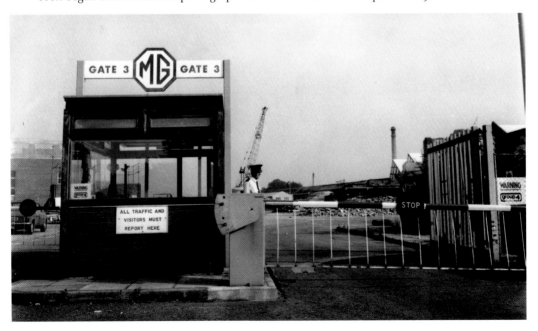

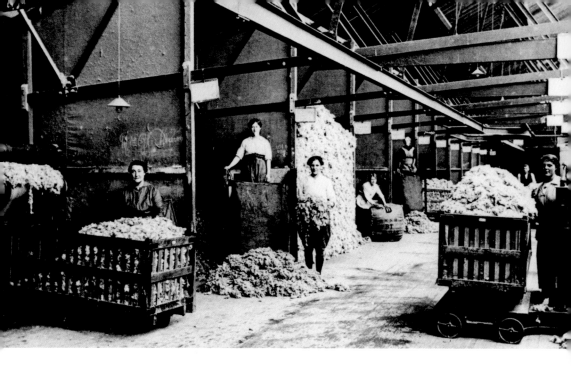

## The Pavlova Tannery and Abingdon Business Park

Workers at the Pavlova tannery during the First World War. The company was founded in 1913 and continued in business after MG cars moved to share the site. It only ceased production in 1994 and in the late 1990s it was decided to redevelop the area for housing and offices. The MG car factory site itself, meanwhile, was redeveloped in the 1980s as Abingdon Business Park, designed to attract firms with a technological bias. At the entrance to the Business Park was the new Thames Valley Police headquarters, opened in 2000 and standing on Colwell Drive. Colwell Drive itself ran through the Business Park, following the line of the old MG factory entrance from Marcham Road.

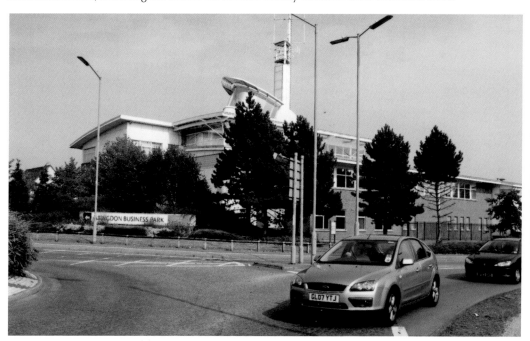

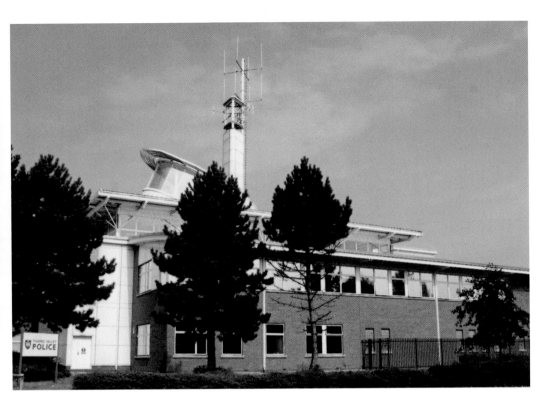

**The Thames Valley Police Headquarters**
Another view of the Thames Valley Police headquarters in September 2009. A plaque commemorated its opening by the Home Secretary on 26 May 2000.

# THAMES VALLEY POLICE

This building was opened by
The Rt Hon Jack Straw, MP
Home Secretary

on

Friday, 26 May 2000

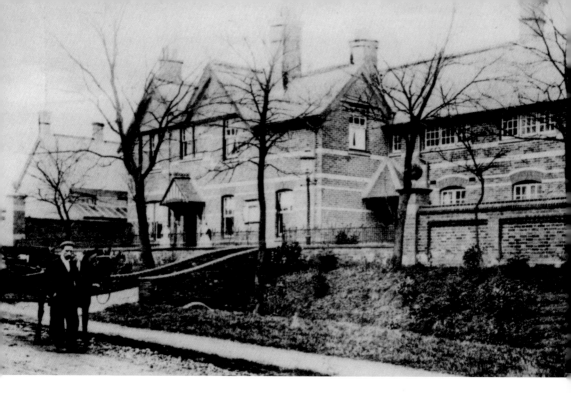

## Marcham Road

The Abingdon Joint Hospital for Infectious Diseases in Marcham Road *c.* 1910. The hospital was opened in about 1900 and in the 1901 Census of Population it had three patients — Harry and Ronald Taylor, aged eleven and nine respectively, who were probably brothers, and a teenage kitchen maid. The resident staff comprised a matron, a nurse, a porter and a domestic servant. In September 2009, the old Isolation Hospital building was still in use as part of the Abingdon Community Hospital. It can be seen through the trees.

### Marcham Road

Two views of the Fairacres trading estate in Marcham Road, which opened in 1969 when Mays Carpets moved from its West St Helen Street shop to the new retail park. By September 2009, the Fairacres estate had much expanded, with many different shops and a large car park. Mays Carpets itself was no longer there.

**Marcham Road**

The Tesco Superstore off Marcham Road in September 2009. It opened in October 1982 amid great excitement. According to the *Abingdon Herald*, 'Traffic was almost at a standstill by mid-morning as scores of shoppers tried to drive to the multi-million pound development. All 600 places at the... free car park were full within an hour.'

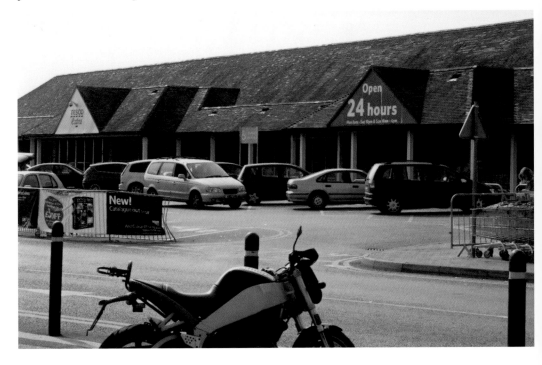

### Caldecott Road

The dry bed of the former Wilts and Berks Canal in the early twentieth century. The canal ceased to operate when an embankment collapsed in 1906 and it was abandoned in 1914. The section shown is parallel to Caldecott Road, with Drayton Road in the background. Even in July 1979 this part of Abingdon retained something of its rural character, as the photograph of Caldecott Road next to the canal bridge shows.

### Caldecott Road and Wilsham Road

By June 2006, housing development had taken place on the Caldecott Road site near to the canal bridge. The former Hygienic Laundry at St Helen's Wharf had closed in 1976. In 1979, its premises at the corner of Wilsham Road were occupied by the JHB Tool Hire shop.

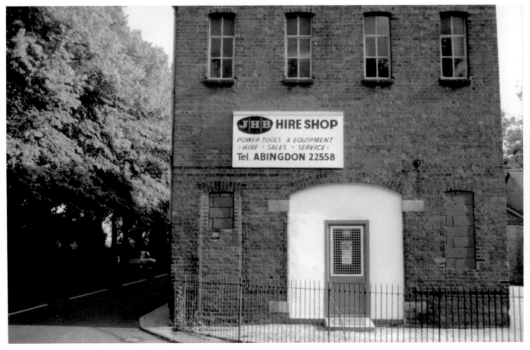

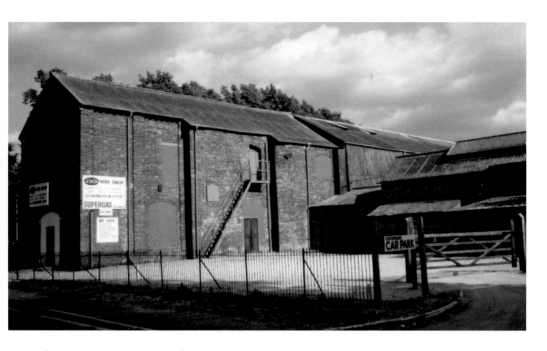

### The Former Hygienic Laundry Site

Another view of the JHB Tool Hire business in 1979. The Hygienic Laundry had been established in former premises of the St Helen's Ironworks — hence the extensive range of buildings now in use by the JHB Tool Hire proprietors. By June 2006, the former Hygienic Laundry site, as viewed from Wilsham Road, had been refurbished and transformed for housing and commercial purposes. What appears to be a white blob on the side of the building is in fact a faint surviving notice of the Hygienic Laundry. It was still visible in 2009.

**The Former Hygienic Laundry Site**
Housing development in June 2006 on the former Hygienic Laundry premises. The site had been sold for housing *c.* 2001.

### Drayton Road

Drayton Road in August 1979, opposite Mill Road, had a miscellaneous collection of buildings on the left of the photograph, including an old community centre. On the right was a new housing estate. By August 2009, the site opposite Mill Road had been developed as Lady Eleanor Court. It was part of a general expansion in housing provision in and around Drayton Road in the late twentieth and early twenty-first centuries, and that was still continuing in September 2009.

# Acknowledgements

I should like to thank all those who have generously provided illustrations or information in helping me to prepare this book. They include Abingdon School and its former headmaster, Mr M. St John Parker; Mr. Les Hemsworth; Mr and Mrs Richard Mathews; Mrs Jill Mitchell; Oxfordshire Photographic Archive and Oxfordshire Studies; Mr Michael Rusher; Mr Mike Spearman; and the late Mr Derek Steptoe and Mrs Steptoe. I am particularly grateful to Mr Hemsworth for his meticulous care in providing many of the modern photographs. Finally, I wish to thank the Hon. Abingdon Borough Archivist, Mrs J. Smith, for her ready co-operation and help, and Mr Paul Power for providing information on Abingdon lock.